MORE THAN ONCE IN A BLUE MOON:

MULTIPLE JOBHOLDINGS BY AMERICAN ARTISTS

MORE THAN ONCE IN A BLUE MOON:

MULTIPLE JOBHOLDINGS BY AMERICAN ARTISTS

Neil O. Alper
and Gregory H. Wassall

Research Division Report #40

National Endowment for the Arts
Seven Locks Press
Santa Ana, California

More Than Once in a Blue Moon: Multiple Jobholdings by American Artists is Report #40 in a series on matters of interest to the arts community commissioned by the Research Division of the National Endowment of the Arts.

First printed in 2000

Library of Congress Cataloging-in-Publication Data
is available from the publisher
ISBN 0-929765-85-0

Printed in the United States of America

Seven Locks Press
Santa Ana, California
800-354-5348

TABLE OF CONTENTS

Chapter 1 Executive Summary

Webster's New World Dictionary defines moonlighting as "the practice of holding a second regular job in addition to one's main job." Unless otherwise noted, in this study a moonlighting worker's main, or primary, job is defined as the one in which he or she works (or usually works) the most hours.[1] It has been recognized for several decades that artists as a group often hold multiple jobs throughout their careers, either by moonlighting or by switching among several short-term jobs.[2] Although the term "moonlighting artist" implies that the artist job is the primary job, artistic jobs can also be, and often are, held as second jobs. Several labor market studies of artists have noted and documented their multiple jobholding behavior.[3] This monograph, however, represents the first systematic study of multiple jobholding by artists.

To place the practice of moonlighting by artists in proper context it is useful to understand (1) why workers in general moonlight, (2) whether artists moonlight for the same reasons, and (3) whether artists in other countries, often working under vastly different support systems, engage in moonlighting practices similar to American artists. As a consequence, this survey is broadened to incorporate a general discussion of moonlighting in the American labor force, and to the extent that information is available, multiple jobholding practices of artists in other countries are also investigated.

Moonlighting in the American Labor Force

A great deal is known about moonlighting in the American labor force, thanks to researchers, using the monthly Current Population Survey (CPS) and longitudinal databases such as the Panel Study of Income Dynamics. However, virtually all these studies have concentrated on issues relating to moonlighting across the entire labor force. Some general findings from these sources are summarized below:

Moonlighting by Gender and Ethnicity

Over the 1970–97 period, the moonlighting rate of all workers has varied from 4.5 percent to 6.2 percent, with rates equal to or greater than 6 percent

1. This is the definition employed in the Current Population Survey, for example.
2. The first study to document moonlighting activities among artists in a quantitative manner was Ruttenberg, Friedman, Kilgallon, Gutchess and Associates (1978). This study focused only on performing artists who belonged to unions.
3. See for example the discussion of multiple jobholding among artists in Wassall, Alper and Davison (1983), and among authors in Kingston and Cole (1986).

throughout most of the 1990s.[4] In the 1970s, the moonlighting rate of men averaged roughly twice that of women, but this gap has narrowed over time. Since 1994, the moonlighting rates of men and women have become essentially equal. In fact, it has been the increase in moonlighting by women that has driven the overall rate upward over this period while moonlighting by men has remained at roughly the same level throughout. Over the same period, the moonlighting rates of whites have consistently been greater than that of blacks and Hispanics.

Moonlighting and the Economy

Moonlighting appears to be pro-cyclical. Although no statistical test of this hypothesis was conducted, a casual observation of moonlighting and unemployment rates suggests that they are inversely correlated. In other words, moonlighting is more common when unemployment is low and the economy is strong.

Moonlighting by Age, Educational Attainment, and Marital Status

Differences in moonlighting rates are also associated with differences in certain other characteristics of workers. Moonlighting tends first to increase with age, peaking in the 36–45 year age bracket, and then declining through the rest of one's working years. Moonlighting also increases at higher levels of education. Married men moonlight more often than those never married and formerly married men. However, married women moonlight less often than formerly married women, who in turn moonlight less often than never married women.

Moonlighting Among Occupations

When examining moonlighting among occupations, it is important to understand that this behavior can be analyzed in two ways. First, one can focus on the occupation of the primary job, in which case moonlighting is defined by those in the primary occupation working in any second job. Second, one can examine the same occupation when held as the second or moonlighting job. Here, the primary jobs held by such workers can be in any occupation.

For example, in 1995 the occupation with the highest percentage of its workers holding any second job was firefighters, with a moonlighting rate of 28.1 percent. In that year there were 24 primary occupations in which workers had moonlighting rates in excess of 10 percent; of those, 4 were artist occupations.

In contrast, the occupation that was most frequently held as a second job was musicians and composers; 39.0 percent of all persons working this occupation

4. These rates refer to the percentage of persons in the labor force holding two or more jobs in a given week. Over the course of a year, the percentage of workers who moonlight at any time during the year is higher; one study (Paxson and Sicherman, 1996) placed it at roughly three times higher.

indicated they held it as a second job. In that year, there were 32 occupations in which more than 10 percent of all workers in that occupation worked it as a second job. In 1995, there were 32 occupations with moonlighting rates as a second job in excess of 10 percent. Of these, 7 were artist occupations.[5]

Hours Per Week Spent Moonlighting

Those workers who held a second job have spent roughly the same number of hours at that job over the 1970–97 period. The number of hours per week spent moonlighting has held steady at 13 to 14 throughout the period.

Why Do Workers Moonlight?

Motivations for moonlighting can be complex, and the information available on motivations is limited. Although the Current Population Survey has asked workers why they moonlight (but only at selected times between 1974 and 1991), the choices it offered respondents were narrow; essentially most represented variations on financial motives. Of these, the one most often selected (other than "other") was to pay for regular household expenses.

Economic theory approaches the issue of moonlighting as a problem of constrained hours at the first job. If a worker needs more earnings, why not simply work more hours on the first job? Job market and contractual constraints may limit the hours a person can work on a principal job; hence the need for a second job. This theory has been verified in empirical studies. However, some of these studies have uncovered other motives for moonlighting. Among them are (1) working two jobs in which complementary skills are required, (2) reducing risks of unemployment and low earnings by working in two unrelated occupations, and (3) working a second job to gain skills and contacts unavailable in one's first job. These studies have also reported that taking a second job becomes more likely with (1) lower wages on the first job, (2) higher wages on the second job, (3) younger workers, (4) more educated workers, and (5) less hours worked by one's spouse.

Moonlighting Among American Artists

In many ways, artists are unusual members of the labor force. Since "unusual" is a relative term, it is important to cite a frame of reference. Although all workers represent a possible comparison group to artists, *all professional workers other than artists* are compared instead. This group is typically referred to as *other professionals* throughout the narrative. The eleven

5. While the Census recognizes over 500 "three digit" occupational categories, there are only 11 Census occupations regularly included by the National Endowment for the Arts in their Research Reports.

artist occupations are found within the Census professional workers occupational group. Artists' personal characteristics, in particular their average educational attainment, more closely resemble those of other professionals than other occupational groups. However, artists tend to experience labor market outcomes more adverse than those of most other professionals. Over the past several decades artists have experienced unemployment rates roughly twice those of other professionals and have had annual earnings ranging from 77 to 88 percent of the average earnings of other professionals.[6]

Similarly, artists have higher rates of multiple jobholding than do persons in the overall workforce, higher than even those of other professionals.[7] However, unlike higher unemployment and lower earnings, higher rates of moonlighting in an occupation are economically ambiguous; one also needs to look at the reasons stated for taking a second job before concluding that that choice is made out of financial distress. Thus one has to examine carefully the evidence on moonlighting by artists to determine whether this practice reflects distress, opportunity, or a mix of factors.

The information on moonlighting by artists presented in this report was extracted from monthly Current Population Survey data files. For selected years between 1970 and 1991, the CPS queried all workers about moonlighting practices only in its May survey. Since 1994, most questions about moonlighting practices have been asked every month. Also, between 1970 and 1997 artists ranged between one and two percent of the labor force. Thus for the years 1970 to 1991, this small sample of working artists reporting their moonlighting behavior (or lack thereof) led to the aggregation of the eleven Census artist occupations into four occupational groups in order to gain increased sample reliability. These aggregated occupational groups are (1) architects and designers (both original Census artist occupational categories), (2) performing artists (musicians and composers, actors and directors, dancers, and announcers), (3) visual artists (painters, sculptors, craft artists and artist printmakers, and photographers), and (4) other artists (authors, college and university teachers of art, drama, and music, and artists not elsewhere classified). For consistency of reporting, these classifications are continued for 1994 and beyond, even though the sample size has increased for these years.

6. For more detail, see Wassall and Alper (1999).
7. Recall that a "multiple jobholding artist" is one who is an artist in his or her primary job.

Artist Moonlighting Rates

As noted, artists moonlight more frequently than all workers in the labor force. They also moonlight more frequently than other professional workers. Rates of moonlighting by all artists ranged from 7 to 14 percent between 1970 and 1997. In every year, they exceeded the moonlighting rates of other professionals; over the period they averaged 40 percent (about 3 percentage points) higher. Other professional moonlighting rates exceeded those of all workers in every year as well.

Within the artist occupation groupings, some consistent distinctions can be observed. The highest rates of multiple jobholding were experienced by performing artists and by other artists, each peaking at just below 20 percent in some years. In most years, visual artists experienced lower rates of multiple jobholding, and architects and designers still lower rates.

Artist Moonlighting by Gender and Race

An examination of moonlighting by gender and race shows patterns that are not quite the same as those of other professionals or of the entire labor force. In virtually all years, both men and women artists moonlighted more frequently than their other professional counterparts. However, while moonlighting by other professional women rose gradually throughout the 1970–97 period (as it did for all women in the entire labor force), women artists had relatively constant moonlighting rates. Throughout this period, they held second jobs at rates approximating those of men.

Because of small sample sizes, moonlighting rates of whites were compared only to all other races, called "non-whites." Among artists, the moonlighting rates of whites were higher in 12 out of 18 years. However, this pattern of greater multiple jobholding by whites was even more consistent among other professional workers; whites had higher rates in all but three years. White artists consistently moonlight more often than white professionals; their rates were higher in all but two years. Non-white artists had higher moonlighting rates than non-white professionals in all but six years.

Artist Moonlighting by Age, Educational Attainment, and Marital Status

There was no consistent pattern of moonlighting rates among artists when broken into age groups. Younger artists often had moonlighting rates as high as, or higher than, older artists. This seems to be consistent with the often-observed phenomenon of young artists finding it difficult to "make it" in their chosen careers, and thus needing to fall back on other sources of income. Other professionals, like all workers, showed moonlighting patterns that first

increased with age, most frequently up to the 36–45 age bracket, and then declined across the remaining age brackets.

Artist moonlighting is positively related to greater levels of education. The most prominent reflection of this trend is that in 15 of 18 survey years, the highest rates were observed for artists with over 16 years of education. A similar pattern holds for other professional workers, but the pattern of increasing moonlighting rates with increasing education is smoother.

There was little or no pattern to moonlighting by marital status among artists. Among other professionals, never-married professionals typically held multiple jobs more frequently, probably reflecting the higher percentage of women in this occupational group.

Artist Moonlighting by Region

Breaking the country into four regions, it was found that artist moonlighting rates are highest in the west and mid-west. The highest moonlighting rates for other professional workers usually occurred in the west.

Characteristics of the Second Job

There were greater differences in hours worked on the first job between artists and other professionals than in hours worked on the second job. Other professionals averaged almost 38 hours a week in their first job, over 4 hours a week more than artists. The time spent by moonlighters on the second job was virtually the same for both groups, averaging just over 12 hours.

The most common type of second job held by artists was a job in the professional and technical occupations, including that of artist. Between 1970 and 1997, between 55 and 75 percent of artists with second jobs held them in these occupations. However, since 1985, the number of moonlighting artists holding a second job as an artist fell from about three in five to one in three. Over the same time interval, the number of moonlighting artists holding second jobs in the professional and technical field *other than artist* rose from about one in ten to one in three. Despite the often-cited stereotype, just under 20 percent of moonlighting artists (one in five) held second jobs in sales, clerical, or service occupations.

Moonlighting Artists Versus Non-Moonlighting Artists

In any given week, the majority of artists do not moonlight. The differences between artists who moonlight and artists who do not are the same as those that have shown up in studies of moonlighting in the entire work force. Artists who moonlight tend to be younger, better educated, more likely to be men, and more likely to be white. Although artists without a second job worked three

hours per week more in their primary job, the total weekly hours worked (first plus second job) of moonlighting artists were nine hours greater.

Artist Occupations as Second Jobs

The artist occupations are also common choices as second jobs for those with primary jobs in other occupations. Among the four artist occupational groupings, performing artist was the most common choice for a second job, followed by other artist, visual artist, and architect/designer in that order. Moonlighting workers who were artists in their second jobs were older, better educated, more likely to be men and more likely to be non-white than moonlighters who were artists in their first jobs. Moonlighters who worked as artists in their second jobs worked four hours a week more in their first job but worked over an hour per week less in their second (artist) job than moonlighters who worked as artists in their first jobs.

Reasons for Moonlighting

When asked by the CPS why they moonlight, artists most frequently indicated that they did so to meet regular household expenses. Although this also was the most frequently cited reason by other professionals, they cited it less frequently. Meeting household expenses is consistent with the constrained hours theory of multiple jobholding: the need to take on a second job, instead of working more hours at one's primary job, to make ends meet. Among artist occupational groups, this reason was checked least often by architects and designers—occupations which more closely resemble the "traditional" professional occupations than other artist occupations.

Enjoying the work on the second job was the reason given second most often by artists for moonlighting. This reason was also the second choice of other professionals, and was chosen as frequently by them. The artists' third choice was the desire to obtain a different experience; for other professionals the third choice was "other."

When non-artists work as artists in a second job, the relative frequency with which they offered the above reasons for moonlighting were significantly altered. Compared to moonlighters working as artists in their main job, persons working as artists in a second job more often cited enjoying the work and obtaining a different experience, and less often cited the need to meet regular household expenses, as reasons for moonlighting.

Information on Moonlighting from Surveys of Artists

Besides the CPS, one-time surveys of artists reveal additional information about multiple jobholding practices. These surveys have often asked artists whether they held any jobs other than their primary artist job *at any time during the course of a year*, but not whether they held two or more jobs in the same week. The reported annual rates of multiple jobholding in these surveys naturally will exceed the rates of moonlighting in a given week reported by the CPS. Another difference found in these studies is self-selection; virtually everyone surveyed self-identifies (and is classified) as an artist, even if more time is spent working in a non-artistic occupation. However, these studies permit the exploration of other issues, such as the amount of time spent in different jobs throughout the year, the earnings derived from different jobs, and in some cases, more detail about the nature of the second jobs and why they were chosen.

The most thorough explanation of these issues can be found in Wassall, et al (1983). In that study of over 3,000 New England artists, the authors found that only 24 percent of the artists surveyed reported that they worked only in their artist jobs during 1981.[8] Other studies have revealed similar statistics. For example, Ruttenberg, Friedman, Kilgallon, and Associates (1981) found that 61 percent of performing artists held jobs in 1976 not in their primary profession.[9] Also, Kingston and Cole (1986), in their survey of authors, found that 70 percent had earnings from work outside their profession. In addition, Netzer and Parker (1993) reported that 80 percent of choreographers surveyed in their study held second (or additional) jobs in 1989.[10]

Wassall et al also reported on weeks worked in and earnings from all three types of job. In 1981, New England artists worked 36.1 weeks as artists, 17.3 weeks in arts-related jobs, and 11.8 weeks in non-arts-related jobs. These numbers exceed 52 because much of the time spent in these jobs involves true moonlighting—working in two or more jobs at the same time. Artists' earnings in 1981 were distributed in the following manner: 41.0 percent from arts work, 30.3 percent from arts-related work, and 18.7 percent from non-arts-related work.[11] Both the Census and the monthly CPS attribute all earnings to the primary occupation, and thus reveal nothing about the sources of earnings of

8. Other jobs were defined as "arts-related" or "non-arts-related." Among the arts-related occupations were teaching in one's art which, at the college level, is defined by the Census as an artistic job.
9. This survey was limited to performing artists who were members of a performing arts union.
10. All these studies measured the number of second jobs held throughout the survey year, rather than in a reference week, as the CPS does.
11. Similar results were found in a follow-up study of artists in Rhode Island. See Alper and Galligan (1999).

multiple jobholders. The artist survey evidence suggests that this Census procedure gives an incomplete picture of how artists earn a living.

These surveys often ask artists about reasons for taking a second job. In the 1981 New England survey, "better pay" was the most frequent response, followed by, in descending order, "better job security," "not enough artistic work," and "complements artistic work." In the 1976 survey of performing artists, "not enough work as a performing artist" was the most frequent response, followed by "complements your work as a performing artist," and then "greater job security."

Given the evidence from the CPS and from direct surveys, artists' moonlighting behavior, though complex, can be summarized as follows. Those who work as artists in their primary jobs utilize the second job as a source of extra income, particularly during the intervals, which occur most frequently in the performing arts, when little art work may be available. Because sporadic employment opportunities are a common phenomenon in the arts, the end result is higher moonlighting rates for artists than in most other professions. Those who work as artists in their second jobs are more likely to be either trying out the artistic job as a new profession, or recognizing that their art job cannot provide sufficient earnings to support them. Second job artists are less likely to hold their art job because of hours or income constraints on their first job.

Multiple Jobholding by Artists in Other Countries

Since there are differences in government attitudes toward artists and differences in the openness of labor markets across countries, it is interesting to see whether moonlighting is a common practice of artists everywhere. It is especially interesting to compare the labor market experiences of American artists to those of artists in countries where there are explicit policies of financial support for working artists.

In some countries, data exist which enable such comparisons. However, these data are not completely comparable across countries. Also, they were collected through direct surveys of artists, and report on multiple-jobholding over a period of time (typically a year) rather than on moonlighting during one week. The most surprising finding gleaned from a review of these studies is that multiple-jobholding by artists occurs at roughly the same rates in all of these countries.

For example, evidence from Finland, a country with strong government support for artists, shows rates of multiple-jobholding comparable to those in the United States. One survey noted that only 21 percent of fine artists held no other job outside their occupation, though levels of multiple-jobholding among performing artists were lower (Karhunen, 1998). A survey of Dutch visual

artists reported that more than one-third of their earnings came from teaching and more than one-quarter of their earnings came from non-arts work (Rengers, 1998). The Netherlands government also provides extensive support for artists.

In a similar survey, 20 percent of Canadian visual artists reported working in some type of job outside their occupation (Bradley, 1978), as did 63 percent of writers in another Canadian survey (Harrison, 1982). Several surveys in Australia have turned up comparable results. For example, Throsby and Thompson (1995) found that in 1988 almost three-quarters of artists held some other job in addition to their artistic work. A 1994–95 survey of British visual artists found that only 11 percent earned all their income from working as artists. Although these three countries have economic systems more like the United States, their governments also support individual artists more extensively than the United States.

Given the United States' history of minimal government support for working artists, one would expect that an explicit policy to limit the need for multiple jobholding would be very low on any political agenda. The presence of similar multiple jobholding rates in countries which administer programs of financial support for artists suggests that such traditional public support, whatever it accomplishes, does little to reduce artists' choices to hold second jobs. The unique characteristics of the artist labor market make it very likely that its high moonlighting rates (as well as its high part-time jobholding rates) will persist in the future.

CHAPTER 2 MOONLIGHTING IN AMERICAN LABOR MARKETS

The major objective of this study is to investigate and report on multiple job-holding by artists. The phenomenon of multiple jobholding, however, is prevalent in the entire labor market, although at different rates in different occupations. This chapter reviews and summarizes the state of knowledge about moonlighting activities in American labor markets.

The research on moonlighting has focused on two broad areas. One involves measuring the extent of multiple jobholding in the economy, both over time and across occupations, using large labor market databases. The other involves using economic models of labor markets to unearth the reasons underlying decisions to moonlight. A survey of the work in these two areas is presented in this chapter.

There are several dimensions to the issues raised by multiple jobholding. These can be summarized in the following four paragraphs:

(1) The most basic set of questions can be addressed using *descriptive information about moonlighting practices*. The first question to be addressed with this information is: How widespread has moonlighting been in the American work force? This leads to several related questions, such as: Is multiple job-holding growing over time? Is it concentrated in certain occupations and not in others? Are there differences in rates of multiple jobholding across gender or race? Do age, family status, and education affect choices to moonlight? What reasons do workers themselves give to explain their moonlighting behavior? All these questions are addressed in this chapter, primarily by citing findings from the Current Population Survey.

(2) A second set of questions addresses factors affecting decisions to moonlight in a more rigorous framework. Here the results of economic studies are examined to gain greater insight into the reasons behind workers' decisions to hold second jobs. By using multivariate statistical models of moonlighting behavior, hypotheses relating to the factors affecting moonlighting choices can be held to tests of statistical significance. These models enable economists to examine issues such as: Why do workers moonlight? Do financial reasons dominate, or are issues such as the lack of full-time work or inflexibility in hours at the primary job, important as well? How do wealth, family size and the presence of a working spouse affect moonlighting choices? What factors affect the

length of time that workers hold second jobs? These issues are also discussed in this chapter.

(3) A third set of questions—the core of this study—addresses *multiple jobholding among artists* in the United States. A similar set of questions emerges regarding the degree and extent of moonlighting and factors affecting the decision to moonlight. Has the rate of multiple jobholding among artists changed over time? Is it higher than in comparable professions? What kinds of jobs do artists hold when they hold more than one? Is moonlighting related to measures of career success? These questions are addressed in Chapter 3.

(4) A fourth dimension is the comparison of moonlighting practices of artists across different countries. Do artists in all countries engage in multiple jobholding? Do they engage in unusual amounts of multiple jobholding? Is the extent of moonlighting related to the amount of external support for artists? Are there other factors that influence the rate of multiple jobholding in other countries not present in the United States? These issues are addressed in Chapter 4.

Tracking Multiple Jobholding in the United States

To measure and track a complex phenomenon such as multiple jobholding requires a random, comprehensive and regularly updated database of persons in the labor force. To document multiple jobholding behavior within occupations such as artists, who constitute less than two percent of all workers, further requires that the database be large. (An alternative is to conduct direct surveys of artists that focus on their labor market behavior.) Some of the longitudinal databases available to social scientists have extensive information on multiple jobholding of workers. However, given the sample sizes of these databases, it is generally possible to analyze moonlighting activity only for all occupations combined. A larger database is required for an examination of moonlighting in narrowly defined occupations, such as artists.

The necessity for larger sample sizes points researchers to the Decennial Census and the Current Population Survey (CPS). The Census, unfortunately, has never asked respondents any questions about multiple jobholding. However, information about this phenomenon can be found in the CPS.

The Current Population Survey is a monthly survey of about 50,000 randomly selected households, and is used to provide basic demographic, labor force, and income information about Americans.[1] Selected households participate in this

1. For example, the unemployment and labor force statistics released monthly by the Bureau of Labor Statistics are drawn from information collected by the CPS. The CPS is also the source of annual reports on the poverty status of Americans and the distribution of income within the country.

survey for a total of eight months.[2] Although the CPS provides information on several hundred attributes and characteristics of persons in the survey, not all information is collected every month. For example, its frequency of coverage of multiple jobholding has been inconsistent.

From 1970 to 1980 information on multiple jobholding was requested of households in the CPS only once a year, as part of its May survey. During the 1980s and early 1990s, the collection of multiple jobholding information became sporadic. Information was collected and released in May 1985 and May 1989, and again in May 1991. In January 1994 the CPS was redesigned, and information on multiple jobholding has been collected and released monthly since then. Some questions on this topic are asked of every respondent each month; however, a more detailed set of questions is asked of a quarter-sample each month.[3] Much of the information presented in the section below is compiled from various Current Population Surveys. Virtually all of the information presented in Chapter 3 on the moonlighting practices of artists comes from the CPS.

Multiple Jobholding in the United States: Some Basic Information

As noted, most of the information on multiple jobholding presented below is drawn from the CPS, either from survey articles and releases published occasionally in the *Monthly Labor Review*, or from the authors' own tabulations using CPS raw data files. The additional information on moonlighting presented later in this chapter is drawn from studies which have relied on several longitudinal surveys of American workers.

Before discussing findings from the CPS it is important to understand how this survey defines and measures multiple jobholding. Respondents are asked questions about their work behavior during a reference week, typically the week prior to the administration of the survey. Those who indicated that they worked during that week are then asked if they held more than one job. In asking questions about other jobs held, the survey defines the *main job* as "the one at which you usually work the most hours." The second job (or jobs) is referred to as the "other job."[4] The CPS then defines a multiple jobholder as someone who either had a job as a wage and salary worker with two employers or more, combined

2. More precisely, they participate in the survey for four consecutive months, are "rotated" out of the survey for four months, and participate for a final four months period.
3. All respondents are asked if they had more than one job last week. If they answer yes, they are further asked about the number of jobs they held and the hours worked at each job. A quarter of the sample (the "outgoing rotation" of survey participants) is asked more detailed questions about the class of worker, industry, and occupation of the second job.
4. The statements inside quotations are taken directly from the survey questionnaire.

a wage and salary job with self-employment, or combined a wage and salary job with one as an unpaid family worker during the reference week. Persons with combinations of two or more self-employment jobs and unpaid family jobs are not counted as multiple jobholders.[5]

As noted, prior to 1994 annual information on multiple jobholding was found only in the May survey (when available at all). Since 1994, core questions about holding extra jobs have been asked monthly, and comparable information from the CPS since 1994 reported herein is taken from the twelve-month sample. This may make the statistics cited for 1994 and subsequent years not entirely comparable to the "May only" statistics for prior years. On the other hand, the twelve-month sample is more statistically valid and accurate. Nevertheless, the CPS provides a consistent summary of how the practice of moonlighting has evolved between 1970 and 1997.

Trends in Moonlighting: 1970–1997

The most basic piece of information that can be examined from this source is how *rates of multiple jobholding* have evolved over this period, and how these rates vary with personal characteristics.[6] Rates of multiple jobholding between 1970 and 1997 are shown in Chart 2.1. Since 1970, the rate of moonlighting dropped to a low of 4.5 percent in the mid 1970s, and since then has gradually risen. In the 1990s it has held steady at over 6 percent. Though a complete annual time series is lacking, moonlighting rates appear to be pro-cyclical, positively related to employment rates and inversely related to unemployment rates.

Moonlighting Trends by Gender

Detail is also available on moonlighting by gender, race, age ranges, marital status and educational attainment. Differences in moonlighting practices by gender can be seen in Chart 2.2. Over the 1970–97 period, moonlighting by men remained relatively constant in the 5–7 percent range. Moonlighting by women, however, rose from just over 2 percent to over 6 percent. Rates of moonlighting for men and women are now virtually identical. Thus the growth in the overall rate of moonlighting can be largely attributed to the growth in holding of multiple jobs by women.

5. For more detail, see Stinson, (1997).
6. The information reported herein on moonlighting rates for all workers men, women, whites and blacks between 1970 and 1991 is taken from Stinson (1997). The rates between 1994 and 1997 are calculated by the authors.

Moonlighting Trends by Ethnicity

Over the same period rates of multiple jobholding by ethnicity can be examined, as shown in Chart 2.3. Because of small sample sizes, only white versus black and Hispanic moonlighting rates are reported.[7] Multiple jobholding rates of Hispanics were not reported in the CPS until 1977. Over the entire period, whites have been more likely to hold multiple jobs than blacks or Hispanics, and since 1989 blacks have been more likely to hold multiple jobs than Hispanics. Moonlighting rates for all three ethnic groups are higher in the 1990s than in earlier decades.

Moonlighting Trends by Age Range

Moonlighting rates by age group are presented in Table 2.1 for the years 1970, 1985, and 1997, years which represent the beginning, midpoint and end of the CPS time series.[8] In each year, moonlighting rates for all workers rise with age and then decline after the 36–45 age bracket, likely reflecting increasing security at one's primary job and then, ultimately, the general withdrawal from labor force activity that occurs with aging past 50. In all years, the rate of moonlighting starts lower in the 16–25 bracket. However, relative to other brackets, women moonlight more frequently in the 16–25 bracket, and less frequently in the over 65 bracket. Using data from the 1984 Survey of Income and Program Participation (SIPP), Conway and Kimmel (1992) observe that moonlighters in their sample are younger than are other workers.

Moonlighting Trends by Marital Status

Marital status (Table 2.1) has an effect on moonlighting rates as well. The data show a consistent pattern of gender differences. While never-married women moonlight more than their married and non-married counterparts, married men moonlight more than their never- and non-married counterparts. This relationship is consistent with several well-known labor market behaviors. One is that, despite labor force advances, the married woman's labor supply may still be considered secondary to the man's within the household. When income or hours constraints are met, the man more typically works an extra job. Further, traditional gender roles when children are present in the household constrain the women's leisure time (and thus her potential time for moonlighting) more than the man's. In their sample from the SIPP, however, Conway and Kimmel find that moonlighting men are more likely to be single than non-moonlighting men.

7. Prior to 1977, data reported by Stinson for blacks included all races other than whites.
8. The information on multiple jobholding by age group and marital status are from Stinson (1986) for 1985. The 1970 and 1997 statistics are from authors' calculations.

Moonlighting Trends by Educational Attainment

Examining moonlighting rates by level of education reveals a gradual increase in this practice with increasing amounts of education. The only exception is the lower rates experienced by those with professional degrees. This exception is probably explained by the typically long hours and high compensation of persons in occupations requiring professional degrees. Both these factors would work against moonlighting. These findings are again consistent with data from the SIPP, as reported by Conway and Kimmel. Moonlighters in the SIPP had almost one more year of education than other workers.

As noted, the moonlighting rates extracted from the CPS are based on workers' behavior during the week prior to the survey. It is likely that some workers surveyed by the CPS might not hold a second job at the time of survey, but may do so at some other time during a calendar year. Much higher rates of multiple jobholding during an entire year are reported using annual data. For example, Paxson and Sicherman (1996), using data from the Panel Study of Income Dynamics (PSID), report that in the years 1976 to 1989, multiple jobholding rates for men averaged 21.1 percent; for women the average was 12.2 percent.[9] This suggests that workers do move in and out of second jobs over the course of a given year.

Moonlighting Frequencies Among Occupations

It has been demonstrated that the rate of multiple jobholding varies considerably among occupations. Amirault (1997), in an examination of 1995 CPS data, identifies 24 3-digit primary occupations in which more than ten percent of workers held other jobs, shown in Table 2.2. Heading the list are firefighters with a moonlighting rate of 28.1 percent. Rounding out the top five are physicians' assistants, announcers, artists not elsewhere classified, and psychologists. Four of the 11 artist occupations regularly reported on by the Research Division on the National Endowment for the Arts appear in the top 24. (Artist occupations appear in capital letters in this table.) In examining the nature of occupations on this list, Amirault observes that moonlighting "is driven more by the opportunities that highly trained and educated workers have to obtain additional jobs than by a need for earnings to meet basic living expenses" (p. 11) .

9. Some examples: In 1976 the CPS reported 2.6 percent of women and 5.8 percent of men holding multiple jobs during the reference week. The PSID, in the same year, reported 11.0 percent of women and 22.9 percent of men holding multiple jobs at some time during the year. In 1985 the CPS reported rates of 4.7 percent for women and 5.9 percent for men; the PSID reported rates of 14.8 percent for women and 20.5 percent for men. (Paxson and Sicherman, 1996, Table 1, page 360).

Amirault also identifies 32 occupations that more than 10 percent of workers held as second jobs (Table 2.3). The highest rate of second jobholding within an occupation was 39.0 percent for musicians and composers. Rounding out the top five in this ranking were news vendors, athletes, announcers, and street and door-to-door salesworkers. Seven of the eleven artist occupations appear in this top 32. There is considerable overlap between occupations in this list and the primary job moonlighting list.

Evidence also exists on how the frequency of moonlighting is related to weekly wages. For example, Amirault reports on weekly earnings of moonlighters in the primary job. Breaking reported weekly earnings into quintiles, he finds that increased earnings are associated with lower rates of multiple jobholding. Less information is available on weekly earnings in the second job. Paxson and Sicherman (1996) report a ratio of mean wage in the second job to mean wage in the first job of 1.84 for men and 1.72 for women, based on data from the PSID between 1976 and 1989. They also report ratios of 1.20 for men and 1.14 for women using data from the 1991 CPS.[10] However, they caution that these figures could be biased because of large amounts of missing observations in both data sets.[11]

Time Spent in Second Jobs

The CPS also provides information on hours per week spent moonlighting. Hours devoted to a second job, for those who had second jobs, are reported in Table 2.4. From 1970 to 1980, median hours are reported; for 1985 and after, mean hours are reported. These data do not show any growth or decline in hours worked over this period. However, there are some consistent patterns. For example, men work more hours in second jobs than women, and blacks and Hispanics work more hours in second jobs than whites.

Reasons for Moonlighting

Prior to 1994, the CPS asked moonlighters to choose among a menu of reasons why they held second jobs. The responses to this question are also tabulated in Table 2.3 for selected years starting in 1974. Unfortunately, the choices allowed in the CPS do not include some of the principal reasons for moonlighting that show up in other surveys. Respondents were asked to pick among the following reasons: to meet regular household expenses, to pay off

10. Ratios of *median* wage on second to first job are lower, roughly 1.0 from the PSID sample and less than 1.0 from the CPS sample.

11. Conway and Kimmel (1992, 1995) also have information on wages in the primary and secondary jobs. However, they define the primary job as the one for which the individual has the highest earnings, potentially biasing observed wage rates in the primary and secondary jobs.

debts, to save for future contingencies, to gain experience in the second job, and "other." They were allowed to choose only one reason.

In most years the reason most frequently picked was "other," with the need to meet regular household expenses ranking mostly second and occasionally first over the same period. These two reasons were commonly cited three to four times as much as any other. Ranking third in most years was saving for future contingencies, followed by gaining experience and paying off debts.

The above discussion summarizes what is known about the frequency of moonlighting, the nature and characteristics of persons who moonlight, the occupations in which moonlighting is most prominent, and the reasons individuals gave when asked why they moonlight. One may draw tentative conclusions from this discussion about some apparent relationships between personal, family, or job characteristics and the probability and frequency of holding multiple jobs. However, the factors affecting moonlighting behavior are often complex and interrelated. For example, moonlighting rates were shown to increase with increasing years of education, but more education leads to a higher income in the primary job, which by itself would predict a lower probability of moonlighting. Issues such as these are better sorted out in the context of econometric analysis of models of moonlighting behavior. A survey of these studies follows.

Why People Moonlight: Theory and Evidence from Empirical Studies

In this section, the empirical literature on the determinants of moonlighting behavior is examined. Specifically, the results of econometric studies of moonlighting behavior are discussed. All these studies employ some form of regression analysis, in which the dependent variable reflects some measure of moonlighting behavior, such as the percentage of the sample that moonlights, the number of second jobs held during the period of analysis, or the length of the second job. These studies typically analyze moonlighting using longitudinal databases. Longitudinal databases often contain more information about characteristics of the first and second jobs than the CPS. For example, since they cover labor market behavior of persons over a length of time, they may provide information on the number of moonlighting episodes per year, and the length of these episodes.

As noted above, a drawback of longitudinal databases is their smaller sample sizes. Because of this, these studies have largely focused on general issues that span the entire labor force.

Research in this area evolves from and tests the implications of the basic economic model of labor supply found in any labor economics textbook. Standard

economic theory of labor-leisure choices predicts that a person determines how many hours to work at the current wage rate based on preferences for more income versus more leisure. As the wage rate rises, the model does not unambiguously predict that a person will work more hours (or less). Offsetting factors are: (1) a higher wage implies a higher opportunity cost of not working, so the worker substitutes hours worked for hours spent on leisure activities (the *substitution effect*), and (2) a higher wage means a higher income from working a given number of hours, causing hours worked to fall as the person spends more time pursuing now affordable leisure activities (the *income effect*). At any possible wage rate an equilibrium trade-off between income and leisure can normally be attained, as long as the worker can choose the number of hours worked per period of time.

A person's desire to take on a second job depends on whether it is possible to work enough hours in the primary job to satisfy income-leisure objectives, reaching the equilibrium noted above. If the primary job is hours constrained, a person cannot reach this equilibrium trade-off and may choose to work additional hours at a second job. Hours will be worked on a second job as long as its wage rate exceeds the worker's reservation wage. The reservation wage, in turn, does not have to be greater than the wage rate on the primary job, but must raise the worker's level of utility (satisfaction) from working the extra hours.

Because of the offsetting income and substitution effects of labor supply, one cannot predict whether a worker will work more or less hours in the second job if the wage in the primary (hours-constrained) job goes up. Similarly, one cannot make unambiguous predictions about the effect on hours worked in the second job when the number of constrained hours on the primary job goes up.

The implications of this basic model have been tested on empirical data by several authors. These empirical studies have generally yielded results consistent with theory. In one of the earliest empirical papers, Shisko and Rostker (1976), using information from the Income Dynamics Panel, examined factors affecting the number of hours worked on the moonlighter's second job. They found that an increase in the wage rate of the second job, a decrease in the wage rate of the first job, and a decrease in the number of hours worked on the first job were all correlated with an increase in hours worked on the second job. All these findings are consistent with the basic theory outlined above. Shisko and Rostker also find that a larger family size (viewed as a proxy for greater spending needs) was associated with more hours spent moonlighting, and that hours spent moonlighting diminish with age.

In addition to hours constraints, moonlighting may be encouraged by liquidity constraints. Abdukadir (1992) investigates this issue using data from

Florida Consumer Surveys. In this model the dependent variable is the decision to moonlight. Abdukadir finds that moonlighting is positively and significantly related to age, being a male, increased education and family size, and negatively and significantly related to family income and being married. He also finds a significant positive correlation with an individual's plans to buy a car or a house. He concludes that liquidity constraints (current spending needs in excess of short and long-run income expectations) also create incentives to moonlight. However, he lacks information on hours worked and thus can not test for hours constraints in his model.

Several observations lead to less than full support for the hours-constraint theory of moonlighting. First, the theoretical models define the primary job as the one with the higher wage rate. Yet, noted above, there is evidence that this is not always the case. Second, the vast majority of multiple jobholders have second-job occupations that differ from their first job.[12] One would expect that, for most workers, the most efficient way to moonlight would be to take a second job in the same occupation utilizing the same general and specific job skills.

These observations lead to a discussion of reasons for holding multiple jobs other than simply to make up for a lack of income from hours-constrained first jobs. In general, researchers have focused on three other causes of moonlighting. These other factors can be explained in the context of a job portfolio theory, "in which workers choose packages of jobs so as to optimize over the mean and variance of income" (Paxson and Sicherman, p. 361). Types of job packaging include the following: (1) A limited number of occupations may require skills or traits which are complementary to those needed in different occupations. Some examples include the police officer and security guard, musician and music teacher, and athlete and coach. (2) The primary and secondary jobs may be linked by risk aversion. In this case, holding multiple jobs could be seen as a portfolio of earnings opportunities, in which average earnings from all jobs could be raised while earnings risk is reduced as long as the earnings streams in each job are uncorrelated with each other. Careers in acting and athletics are examples of occupations with substantial earnings risk; thus a second job for persons in an unrelated occupation such as taxi driving or construction may smooth the pattern of earnings over time. (3) A second job may be held because it provides training, networking or contacts that the first job doesn't provide. An example of this phenomenon is moonlighting in a sales oriented job.

12. For example, Paxson and Sicherman note that in the 1991 CPS, 83 percent of men and 72 percent of women who held second jobs held them in different occupations. They also observe that the comparable figures from the Panel Survey on Income Dynamics between 1984 and 1989 were 78 percent for men and 72 percent for women. Occupations were defined at the two-digit level.

It should be noted that several of the moonlighting scenarios described above potentially apply to artists. However, it should be expected that the motives that lead artists to moonlight are complex, and that no single motive will explain all moonlighting behavior by artists.

Conway and Kimmel (1992) directly test the hours-constraint hypothesis against the job-packaging hypothesis. The sample they draw from the SIPP consists of working men between the ages of 18 and 55.[13] They estimate *decision to moonlight* equations and *labor supply* equations, as measured by weekly hours worked, for both the primary and secondary jobs. They find that in their sample most workers have constrained hours in their primary jobs, and conclude that this is the primary reason for moonlighting. But they note that their findings also lend some support for the job heterogeneity hypothesis. Their estimating equations show that hours supplied on the second job are positively related to its wage, negatively related to the primary job wage, negatively related to age, and positively related to the level of education.

Conway and Kimmel (1995), using the same database, estimate hazard functions to test for factors affecting the *duration of the moonlighting episode*.[14] In this model, age, being divorced, and having more children all significantly predict longer moonlighting episodes. The nature of the occupation of the second job is also a significant factor; men in farming, sales, service, professional, and technical occupations moonlight for longer periods. The nature of the primary job did not affect the duration of moonlighting. Also, the level of education is not a significant predictor in this model.

It is useful to compare factors affecting the choice to moonlight that are revealed in the econometric studies cited above to the actual reasons for moonlighting as given by participants in the Current Population Survey. First, the CPS does not offer respondents the choice of an "hours constraint" reason for holding a second job. Second, other than the "experience" option, it does not offer respondents any choice consistent with the job-packaging hypotheses discussed above. Essentially, the CPS limits choices to financial reasons for moonlighting. It is no surprise that the "other" option is most frequently picked by respondents.

Another extension of the theory of moonlighting applies it to married couple households (Krishnan, 1990; Highfill, Felder and Sattler, 1995). Economic theory posits that the household is the decision-making unit, so the choice of one

13. Within this group, men between ages 18 and 25 were excluded, as were men who were self-employed or in the military. In addition, they defined the primary job as the one that had the highest earnings per episode or the most hours worked per week.

14. Specifically, the hazard function shows the probability that a moonlighting episode will end any period t, given that it has lasted t periods already.

spouse to moonlight is to some extent a substitute for the choice of the other spouse to work, or work more hours, or to moonlight as well.

For example, Krishnan (1990) identified 219 moonlighting men in the sample of 4,448 married couples in the Survey of Income and Program Participation in 1984, a moonlighting rate of 4.9 percent.[15] He estimates *moonlighting participation functions* for the entire sample of married men, and *labor supply functions* for the moonlighters' second jobs. He finds that increased labor force participation by wives deters moonlighting by husbands (although the wife's wage has no significant effect on hours spent on the second job). He also finds that longer hours and higher income on the first job deter moonlighting as well (as have others, noted above). These findings are consistent with that part of standard labor supply theory that regards the primary cause of moonlighting to be an hours constraint on the primary job.

Unlike other researchers in this vein, Krishnan utilized information determining the amount of general versus specific training that workers in the sample received.[16] He finds that larger amounts of specific training deter moonlighting when the second occupation is the same as the first. However, larger amounts of general training increase the likelihood of moonlighting but have no effect on hours spent moonlighting.

Conclusion

In general, this review of statistical information on the moonlighting behavior of Americans was drawn from general surveys of the entire work force. Information is most often cited from the Current Population Survey because of its monthly sampling procedure, its relatively large sample size, and its regular questions (once a year for selected years from 1970 to 1991, and once a month since 1994) about moonlighting. However, the CPS does not provide information on some important aspects of the multiple jobholding experience. The CPS does not report on the duration of moonlighting episodes, or the number of times a year that workers moonlight. To examine these and other more complex issues, most researchers have mined longitudinal databases, such as the Panel

15. Both Krishnan and Conway and Kimmel use the 1984 SIPP as the basis of their studies. Each uses a different methodology to identify the moonlighting men in the sample. Each, however, finds moonlighting rates (4.9 percent of married men for Krishnan) that are lower than those found for men in the CPS at roughly the same time (the closest period in the CPS is May 1985, for which the moonlighting rate for men was 5.9 percent).
16. General training (an extra year of college, e.g.) raises general productivity and enhances one's worth at virtually any job. Specific training makes one more productive on one's current job but not others. A computer programmer taking a course to learn C++ would be receiving general training. The same person, when updating company-specific software, is receiving specific training.

Study of Income Dynamics and the Survey of Income and Program Participation. A drawback of these databases is their smaller sample sizes. The statistical limitations posed by these smaller sample sizes have forced the focus of researchers to remain on all occupations combined.

In the next chapter, we examine the moonlighting behavior of artists. Because artists have constituted from one to two percent of the labor force over the 1970–1997 period, we are constrained to using the CPS in our analysis.

Table 2.1
Moonlighting Rates by Personal Characteristics, 1970, 1985 and 1997

Characteristic	All			Men			Women		
	1970	1985	1997	1970	1985	1997	1970	1985	1997
Overall	5.2	5.4	6.6	7.0	5.9	6.6	2.2	4.7	6.6
By Age:									
16-25	3.3	5.3	6.2	4.3	5.3	5.6	2.2	5.2	7.0
26-35	6.3	5.7	6.5	8.1	6.2	6.7	2.5	5.0	6.3
36-45	6.6	6.2	7.1	9.0	7.1	7.2	2.3	5.2	7.0
46-55	5.3	5.1	7.0	7.3	5.9	7.0	1.9	4.1	7.0
56-65	4.1	3.7	5.6	5.2	4.4	6.0	2.2	2.9	5.1
Over 65	3.1	3.2	3.5	3.9	3.5	3.9	1.8	2.7	2.9
By Marital Status:									
Married	5.9	5.3	6.4	7.8	6.2	6.9	1.8	3.8	5.8
Never Married	3.3	5.5	7.4	4.0	5.2	6.6	2.6	6.0	7.9
Widowed/divorced/separated	3.5	5.5	6.5	4.7	5.6	5.9	3.0	5.4	7.3
By Education:									
Less than high school			3.2			3.1			3.4
High school graduate			5.4			5.5			5.2
Some college			7.6			7.7			7.6
Associate's degree			8.6			9.0			8.3
Bachelor's degree			8.0			8.1			7.9
Master's degree			9.0			8.8			9.2
Professional degree			7.1			7.5			6.2
Doctorate degree			10.2			10.2			10.3

Sources: Stinson (1986); Authors' calculations for 1970 and 1997.

Table 2.2
Primary Occupations with Moonlighting Rates of
10 Percent or More, 1995

Primary Occupation	% with 2nd Job
Firefighters	28.1%
Physicians assistants	23.4
ANNOUNCERS	19.3
ARTISTS AND RELATED WORKERS, N.E.C.	16.0
Psychologists	15.6
Therapists	14.5
Dental hygienists	14.4
Teachers, college and university	14.1
Teachers, secondary school	13.3
MUSICIANS AND COMPOSERS	13.0
News vendors	12.3
ACTORS AND DIRECTORS	11.8
Teachers, n.e.c.	11.7
Supervisors, police and detectives	11.7
Hotel clerks	11.4
Administrators protective services	10.9
Police and detectives	10.8
Dietitians	10.8
Bartenders	10.6
Veterinarians	10.2
Editors and reporters	10.0
Managers, service organizations, n.e.c.	10.0
Social, recreation, religious workers	10.0
Pharmacists	10.0

Source: Thomas Amirault, "Characteristics of multiple jobholders, 1995," Monthly Labor Review, March, 1997, 9–15. Artist occupations are in Capital Letters.

Table 2.3
Secondary Occupations with Moonlighting Rates of
10 Percent or More, 1995

Secondary Occupation	% with 2nd Job
MUSICIANS AND COMPOSERS	39.0%
News vendors	35.0
Athletes	34.4
ANNOUNCERS	33.6
Street and door-to-door sales workers	32.3
Teachers, n.e.c.	23.3
ARTISTS, PERFORMERS, AND RELATED WORKERS, N.E.C.	22.8
Bartenders	22.0
Farm operators and managers	20.8
AUTHORS	19.9
Small engine repairers	17.0
Psychologists	16.7
Religious workers, n.e.c.	15.9
PHOTOGRAPHERS	15.6
Teachers, college and university	15.1
Clergy	14.3
Demonstrators, promoters and models, sales	14.2
Guides	14.0
Manager, properties and real estate	13.4
Management analysts	12.7
Guards	12.7
Attendants, amusement and recreation facilities	11.9
Sales workers, retail and personal services	11.9
Janitors and cleaners	11.7
Editors and reporters	11.4
ACTORS AND DIRECTORS	11.3
Animal caretakers, except farm	11.0
Waiters and waitresses	10.8
Physicians assistants	10.6
Therapists	10.4
PAINTERS, SCULPTORS, CRAFT-ARTISTS, ETC.	10.4
Bus Drivers	10.4

Source: Thomas Amirault, "Characteristics of multiple jobholders, 1995," Monthly Labor Review, March, 1997, 9–15. Artist occupations are in capital letters.

Table 2.4
Reasons for Holding Second Jobs and Hours Worked in Second Jobs, 1970-97

Category	Year																	
	1970	1971	1972	1973	1974	1975	1976	1977	1978	1979	1980	1985	1989	1991	1994	1995	1996	1997
Reasons for holding second job (%):																		
Meet regular expenses					32.1	34.6	30.0	33.1	30.4	31.9	31.6	35.5	31.0					
Pay off debts					6.3	5.0	5.4	5.3	6.7	7.0	9.3	8.9	9.1					
Save for future					9.5	9.0	8.3	8.2	9.5	10.5	13.0	16.2	9.0					
For the experience					6.4	6.8	6.6	6.4	8.5	7.6	17.0	14.7	8.3					
Other					45.7	44.7	49.7	47.0	45.0	43.0	29.2	24.6	42.6					
Hours worked in second job:																		
All	13	13	13	13				13		13	13	14.2	13.8	13.1	13.2	13.0	13.0	13.1
Men	14	14	14	14				14		14	14	15.0	14.5		14.1	14.2	13.9	14.0
Women	10	9	11	11				11			13	12.9	13.0		11.9	12.0	12.0	12.0
White	13	13	13	13				10			13	14.0	13.6		12.8	12.9	12.7	12.8
Black	14	15	15	14							16	16.8	17.2		15.3	16.3	15.8	15.4
Hispanic												15.1	15.3		14.4	14.3	15.2	19.3

Notes: Hours worked are reported as medians from 1970 to 1980, and as means thereafter. Sources: Bureau of Labor Statistics, Multiple Jobholding in May, various issues, and authors' calculations.

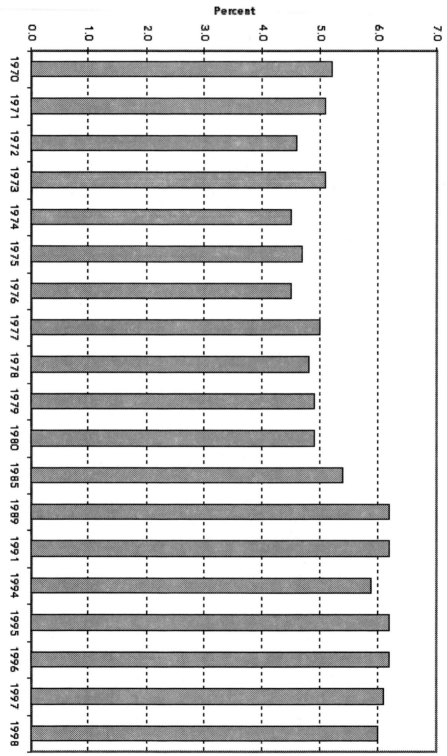

Chart 2.1
Multiple Jobholding Rates: All Workers

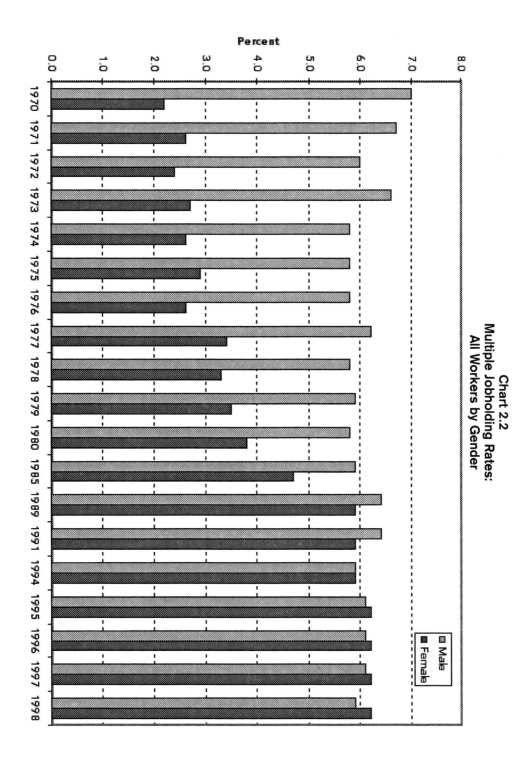

Chart 2.2
Multiple Jobholding Rates:
All Workers by Gender

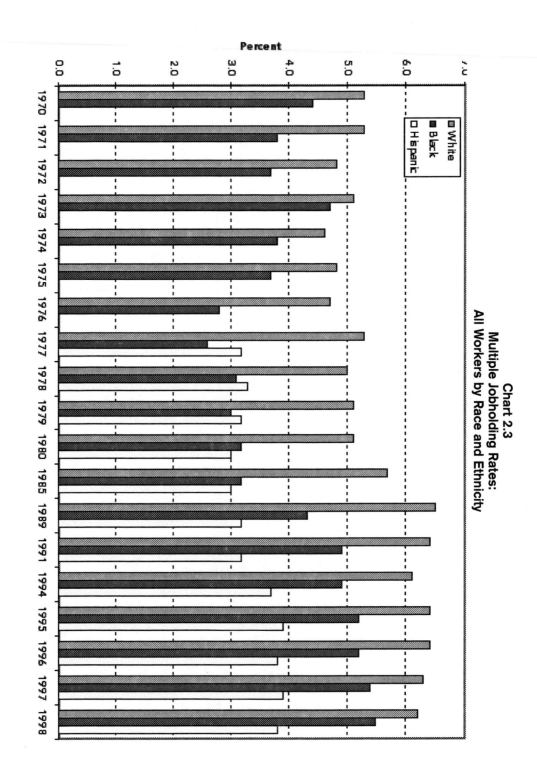

Chart 2.3
Multiple Jobholding Rates:
All Workers by Race and Ethnicity

CHAPTER 3 MOONLIGHTING BY AMERICAN ARTISTS

Introduction

In this chapter several aspects of artists' multiple jobholding behavior for the period 1970 to 1997 are examined. First to be examined will be trends in multiple jobholding rates, i.e., the percentage of people who have indicated that their primary occupation is that of artist but who also indicated that they worked at a second job during the CPS survey week.[1] There will be a comparison of those artists with second jobs to a comparable group of multiple jobholding professional workers (excluding artists, who are also classified as professional workers by the Census and CPS). This will be followed by a comparison of the artists who were multiple jobholders to artists who indicated that they only worked at one arts job. For two somewhat shorter periods, due to changes in the CPS during this twenty-seven year period, there will be an examination of the reasons given by artists to explain why they held multiple jobs (1974–1991). There will also be an examination of the characteristics of those people whose primary occupations were non-artistic, but who indicated that they also held artistic second jobs (1985, 1989, 1991, and 1994 through 1997). Finally, there is an examination of the characteristics of the second jobs held by multiple jobholding artists, and an examination of who the multiple jobholding artists are and where they live.

As discussed in the previous chapter, during the period 1970 to 1980 and irregularly through 1991 (1985, 1989, and 1991), information regarding the multiple jobholding behavior of artists, and for that matter all workers in the United States, was obtained through an annual supplement to the May Current Population Survey. Since 1994 information on multiple jobholding has been obtained monthly through the CPS. Although the CPS surveys between 50,000 and 60,000 households nationwide each month, artists have accounted for between one and two percent of the workforce during the period under study (Alper and Wassall, 1996). This means that the information on the multiple jobholding behavior of artists must be viewed carefully. The estimated averages and percentages reported in the narrative (and in the accompanying charts and tables) have larger statistical errors than do estimates for the entire labor force. The uncertainty of the estimates

1. The CPS is undertaken monthly during the calendar week that includes the 12th day of the month.

becomes increasingly severe as the artists are disaggregated into various groups. The larger the number of groups that are used, the smaller the number of artists there will be in each group, and the less reliable are the estimates. For this reason we have limited the amount of disaggregation.

The CPS-defined artists are combined into four groups based on their primary occupations, rather than the eleven Census groups generally used in National Endowment for the Arts (NEA) research reports. *Architects and designers* are combined into one group. (As noted earlier, the job market for this group most closely resembles that for other professionals.) The Census' musicians and composers, actors and directors, dancers, and announcers categories are combined into a single and relatively homogeneous group of *performing artists*. The *visual artists* group is also relatively homogeneous, and combines the Census painters, sculptors, craft-artists, and artist print-makers category with the photographers category. The fourth group is a catchall group called "*other artists.*" It includes the Census categories of authors, postsecondary school art, drama and music teachers, and artists, performers, and related workers not elsewhere classified. College teachers of art, drama, and music often (though not always) perform or create art as part of their academic work. In other respects they resemble their academic peers, with high educational requirements and a less-than-twelve-month-work year. Artists not elsewhere classified is particularly diverse, encompassing occupations such as calf roper, astrologer, juggler, and clown.

Note that the racial breakdown has been limited to two groups (whites and others), also due to sample size constraints. Further, the geographical breakdown is limited to four regions (northeast, midwest, south and west), and information on the occupation of the second job to four broad groups (professional, managerial and technical workers; artists; sales, clerical and service workers; and other).

The last section of the chapter will explore the multiple jobholding behavior of artists in the United States utilizing surveys that were specially designed for the uniqueness of their experiences. These surveys will be used to confirm the behavior identified by the CPS and to explore questions that cannot be answered by the CPS. Their strength can be found in the recognition that artists' work behavior is, in many ways, unique and cannot readily be captured by national surveys such as the CPS or the Decennial Census. Their weakness is that the information they collect may not be truly representative of all the artists in the country.

Trends in Multiple Jobholding Rates: All Artists

Throughout this twenty-seven year period, artists were more likely to be multiple jobholders than their peers in other professional occupations (Chart 3.1).[2] The moonlighting rates for all artists, which ranged from just under eight percent to almost fourteen percent during this period, averaged almost 40 percent higher than the rate for professional workers. This difference between artists' moonlighting rates and those for professionals ranged from 3 percent to 88 percent.

By Gender

There does not appear to be a readily discernable pattern in the multiple jobholding rates of male and female artists (Chart 3.2). In half the years the rate for men exceeds the rate for women; in the other years the opposite is true. The male artists' multiple jobholding rates range from 8.3 percent to 15.4 percent. The female rates range from 5.8 percent to 13.8 percent. Among professional workers there is a clear pattern of male multiple jobholding rates exceeding female rates throughout this period. In comparison to their professional peers, female artists were consistently more likely to hold a second job. This was true throughout the twenty-seven year period (Chart 3.3). The same cannot be said for the male artists relative to their professional peers. Though in the majority of the years (13 of 18) male artists' multiple jobholding rates were higher than the rates for the other professional males, the differences were not as large as the differences in female rates (Chart 3.4).

By Race

In most years the multiple jobholding rate for white artists was higher than the rate for non-white artists (Chart 3.5). The white artists' multiple jobholding rates ranged from slightly more than seven percent in 1971 to 14.0 percent in 1977. The non-white artists' rates ranged from just under four percent in 1980 to more than 15 percent in 1985. The same pattern held for professional workers. In all the years, except for 1978, the white artists' multiple jobholding rates were higher than the white professionals' rates (Chart 3.6). The pattern was much less consistent for non-white artists compared to non-white professionals. In one-third of the survey years, non-white professionals were more likely to be multiple jobholders than non-white artists (Chart 3.7). A similar, though not quite as consistent, pattern exists when comparing non-Hispanic artists' and

2. The information in the charts in this chapter, and in the appendix, are based on authors' calculations using data in raw CPS files. The tables from which these charts are constructed, as well as additional data extracted from the CPS files, are available from the authors by request.

professionals' multiple jobholding with Hispanic artists and professionals. In general the rates are higher for the non-Hispanics than the Hispanics, but this is less true for the professional workers than it is for the artists.

By Age Groups

There does not appear to be any pattern with regard to the artist's age and the likelihood of multiple jobholding (Chart 3.8). When grouped into 10 year age cohorts, the only pattern that seems to hold across most years is that the artists in the oldest category, those more than 65 years old, tend to have the lowest multiple jobholding rate of all artists. For non-artist professionals the relationship between age and the likelihood of holding a second job follows an inverted 'U' shape for most of the twenty-seven year period. That is, multiple jobholding rates initially increase with age and then decrease. The pattern changed somewhere in the early 1990s; for each year starting in 1994 the youngest cohort of non-artist professionals had the highest multiple jobholding rates.

For most years in the twenty-seven year period, the multiple jobholding rate for artists tended to increase with the amount of schooling they received (Chart 3.9). That is, artists with more schooling were more likely to have a second job than artists with less formal schooling. In the early 1970s the pattern was not as clear, but even during those years (1970–1974) artists with the most schooling, more than 16 years of formal education, tended to have the highest multiple jobholding rates among the artists. A very similar pattern also exists for the other professionals.

By Region

Over the period, artists' multiple jobholding rates tended to vary based on the region of the country in which they resided. The highest rates were found among artists who lived in the mid-west and the west (Chart 3.10). For professional workers, the highest multiple jobholding rates were almost always found among the professionals who lived in the west. This was true for all but five years, with three occurring in the 1994–1997 period.

By Marital Status

The artist's marital status does not appear to consistently affect the likelihood of multiple jobholding. In some years married[3] artists have the highest rates, in others it is the widowed, separated, and divorced with the highest, and in still others it is the never-married (Chart 3.11). For professional workers,

3. From 1970 to 1985 the CPS considered people who were separated but not legally divorced as married. Starting in 1989 the CPS included them with those who were widowed and divorced.

those who indicated that they were never married almost always had the highest multiple jobholding rates throughout the 1970–1991 period. During the 1994–1997 period, widowed, divorced and separated professionals consistently had the highest multiple jobholding rates.

Trends in Multiple Jobholding Rates: Details for Artists' Occupations

Although artist multiple jobholding rates are high, there are consistent differences among the artistic occupations over the 1970–97 period (Chart 3.12). Other artists (authors, post-secondary school art teachers, and artists not elsewhere classified) had the highest average annual multiple jobholding rate of 14.3 percent. For more than half the years they had the highest rate, and for almost a third of the years they had the second highest rate of multiple jobholding. Performing artists had the second highest average rate, 13.4 percent for the period. In more than sixty percent of the years they had the second highest rate and in almost one-quarter they had the highest rate. Visual artists ranked third, with an average rate of 10.0 percent for the period. Architects and designers were by far the least likely to hold second jobs during the period. The average multiple jobholding rate of 7.1 percent was about half the rate of the "other artists." The average rate for the architects and designers was comparable to the average moonlighting rate for all other professional workers, which was 7.7 percent.

A brief reminder is necessary at this point regarding the reliability of estimates because the artists are disaggregated into groups. All the estimates become subject to greater variability about the mean as the number of groups, and the size of the groups gets smaller. While this may not seem to be a problem when examining gender differences, it is important to note that there were some artistic occupations, like architects, where not that many years ago the proportion of women or the proportion of non-whites employed in that occupation was very small. For example, in 1970 only four percent of the architects were women, but by 1995 the proportion had increased to 20 percent female (Katz, 1996, 17).

A closer examination of multiple jobholding rates by gender reveals some interesting relationships related to artistic occupation (Appendix Charts A–3.1 to A–3.4). The decade of the 1970s tended to have the largest gender differences in multiple jobholding rates regardless of artist type. By the 1990s, there was very little difference between the multiple jobholding rates of male and female architects and designers, performing and visual artists. The difference in the

likelihood of holding a second job relative to gender persisted to a greater degree among the other artists.

The volatility in the estimated multiple jobholding rates, due to the limited number of non-white artists in the surveys, is quite apparent when examining racial differences across artistic occupations (Appendix Charts A–3.5 to A–3.8). With the number of minorities in each occupation increasing over the years, it is better to focus on the period after 1980. For the entire post-1980 period, except for 1985, white architects and designers had a greater chance of holding a second job than their non-white colleagues. In each of the other occupations the racial group with the higher multiple jobholding rate varied from year to year.

The age specific multiple jobholding rates for each artistic occupation illustrate almost random variation from year to year and from artist group to artist group (Appendix Charts A–3.9 to 3.12). For example, in 1971 and 1977 two groups of architects, those aged 16–25 and those aged 36–45, had multiple jobholding rates that were in excess of 20 percent. This was the highest of any of the architects' and designers' age cohorts in any other year. In the same years, the same age cohorts among the visual and other artists groups had some of the lowest multiple jobholding rates for the entire twenty-seven year period. It is interesting to note that prior to the mid 1980s it was rare to find any evidence of moonlighting among the oldest cohort, artists over 65, for each artist group. During each survey year since 1989 there is evidence of considerable moonlighting among the oldest artists. The only exception is visual artists.

Moonlighting Artists Versus Moonlighting Other Professionals

As already shown above, multiple jobholding rates for artists differ from multiple jobholding rates for the other workers classified by the United States Census Bureau as professional and technical workers. This section of the report will present a comparison of moonlighting artists to moonlighting other professionals in order to help explain these differences in their moonlighting rates.

An area where there appears to be a difference is in the number of hours worked by the artists who held two jobs compared to the professional workers who also held two jobs. Professional workers averaged significantly more hours per week working at their first job than the artists averaged over this period (Chart 3.13). Professional workers averaged 37.7 hours per week while the artists averaged 33.4 hours at their first job. It is also true, though to a lesser degree, that professional and technical workers worked more, on average, at

their second jobs than artists (Chart 3.14). Professional workers averaged 12.3 hours per week at their second jobs, while artists averaged only 12.1 hours per week, not a significant difference. The number of hours worked on the second job by the artists ranged between 20 percent and 50 percent of the hours worked at the first job over this period. For professional workers the variation was much smaller with the second job hours ranging between 30 percent and 35 percent of the hours worked on the first job.

The gender composition of moonlighting artists changed considerably over this period. The major change appears to have occurred during the 1980s (Chart 3.15). Over the early period of this study, 1970–1980, the percentage of moonlighting artists who were men averaged 72 percent. For the later period of time, 1985–1997, this percentage decreased to 56 percent. While this change was considerable, it was not unique to this group. There was a similar decline in the proportion of men among moonlighting professional and technical workers, and among the artists who were not multiple jobholders. In fact, by 1994 the proportion of female professional and technical workers who were multiple jobholders was greater than one-half.

Multiple jobholding artists were both younger and not as well educated as other multiple jobholding professional and technical workers. This was true throughout the entire period, except for 1997, when multiple jobholding artists were slightly older than multiple jobholding professional and technical workers. Artists with second jobs averaged 36.9 years of age and 15.3 years of formal schooling (excluding 1994–1997, when the CPS changed its method of measuring the amount of formal schooling completed).[4] This does not include schooling outside the traditional primary, secondary and higher education institutions. Professional workers were, on average, 38.2 years of age and had completed an average of 16.2 years of schooling (excludes 1994 to 1997). The average age of multiple jobholding artists at the end of the 27 year period was five years greater than at the beginning, while the average age of the professional and technical multiple jobholders had only increased by a little more than one year.

There was a considerable difference in the proportion of multiple jobholding artists by race over the twenty-seven year period. The proportion minority (non-white) ranged from approximately two percent to almost fourteen percent over the period. The reliability of these estimates is of concern given the relatively small numbers of minority multiple jobholding artists in most years. In

4. Starting in 1994 the CPS measured the highest level of formal school completed or degree received, not years of schooling completed.

most years, a higher percentage of artist moonlighters were white than were other professional moonlighters. However, whites form a higher percentage of total artist employment than of total other professional employment.

Multiple Jobholding Artists Versus Non-Multiple Jobholding Artists

It is clear that artists differ in their multiple jobholding behavior. It was shown above that the artists' multiple jobholding rates vary by type of artist. What follows is a comparison of artists who hold more than one job at a time to those artists who do not.

It's not surprising to find that those artists who moonlight tend to be younger than artists who have only one job. It typically is the younger artists who often struggle to earn enough from artistic work when first starting in the profession, and therefore have to look toward second jobs to help cover expenses. The average age of multiple jobholding artists over this twenty-seven year period was 36.9 years. The average age of artists who did not have second jobs was 38.3 years. By 1997 the average ages for the two groups of artists were essentially the same, with the multiple jobholding artists being slightly older.

Artists who held second jobs tend to have more formal schooling than artists who did not hold second jobs. The annual average for the multiple jobholding artists from this period (excluding 1994 to 1997) was 15.3 years of schooling completed while the average for artists with only one job was 14.4 years of schooling. The high multiple jobholding rate for the "other artists," which includes the post-secondary school art teachers, helps explain this observation.

Two other demographic characteristics of the artists also distinguished non-moonlighting artists from those who held second jobs. Non-moonlighting artists comprised a larger percentage of women than moonlighting artists. For this period an average of 36.7 percent of non-multiple jobholders were female, compared to 34.3 percent of the multiple jobholders. The non-multiple jobholding artists were also more likely to be minority than the multiple jobholders. For the period, an average of 7.0 percent of the non-multiple jobholders were minority, compared to 5.8 percent of the multiple jobholders.

Non-multiple jobholding artists averaged more hours of work at their only job than did multiple jobholding artists did on their primary jobs. Non-multiple jobholders spent an average of 36.3 hours per week working while the multiple jobholders spent 33.4 hours working at their primary jobs. It should be pointed out that the multiple jobholding artists' total time spent working was more than the time spent by the non-multiple jobholders. Multiple jobholders

spent an average of 12.1 hours per week working at their second jobs. Such differences in hours worked between multiple and non-multiple jobholders can be seen in virtually all occupations.

Workers Who Moonlight As Artists

It is well known that some moonlighters with non-artistic primary jobs have second jobs in the arts. Unfortunately, due to data restrictions, it's only possible to examine this group of artists for the period of 1985 to 1997. In this section these second-job artists will be described and compared to moonlighters whose primary jobs are artistic.

Performing artist was the most common second artistic job held by multiple jobholders whose primary job was not in the arts (Chart 3.16). Over this period between 45 percent and 55 percent of moonlighters whose primary occupations were outside the arts but who held second jobs in the arts were performers (musicians, dancers, actors and announcers). One possible explanation for this result is that people working in the performing arts are most likely also to have jobs outside the arts based on the risk-spreading motive for job packaging, that is, to compensate for the sporadic, short-term nature of employment in their field. When the non-arts work consumes more hours than the performing arts work in a given week, the CPS classification shows a non-arts primary job and a second job in the arts.

The next most commonly held second artistic job, in all years except 1997, was that of other artists. Between 17 and 27 percent of the non-artists moonlighters held other artist (authors, post-secondary teachers of art, or artist(s) not elsewhere classified) jobs. Working as a visual artist, (painter, sculptor, artist printmaker, craft artist, or photographer) was the third next most common second artistic job, accounting for between 15 percent and 19 percent of all artistic second jobs. Working as an architect or a designer was the least likely artistic second job.

Those with a primary occupation outside the arts and a second one in the arts were more likely to be men than were primary job artists. On average, 60 percent of those people with second jobs in the arts were men. Among artists who also held second jobs in the arts, the proportion male averaged less, about 56 percent. Only among those who worked as architects and designers as a second occupation (an occupation in which men are more than half of the primary jobholders) did the number of women exceed the number of men. It is not entirely clear why, relative to women, men are more likely to moonlight as artists than to hold primary artist jobs. In the context of a stereotypical husband-wife household,

these behaviors are consistent with the notion of the husband having the primary, more stable job, and flirting with an artist career in a second job. Continuing this logic, it is also consistent with the notion of the wife being a secondary source of income, and thus being able to embark on a riskier career path.

There were several additional characteristics that distinguished multiple jobholders with artistic second jobs from multiple jobholders with artistic primary jobs. Artistic second jobholders were, on average, slightly older, 38.0 years old compared to 36.9 years old. They were somewhat better educated having completed 15.6 years of formal schooling compared to 15.3 years for the artistic primary jobholders. The percentage of non-whites among second jobholders in the arts averaged almost two-thirds more than the percentage among primary jobholding artists.

Another difference between these two groups of artists was the amount of time they spent working at their first and second jobs. Those artists with their primary jobs outside the arts tended to work more hours on their primary jobs (37.6 hours per week) than those whose primary jobs were in the arts (33.4 hours per week). Perhaps not surprisingly, the group whose primary jobs were outside the arts worked fewer hours at their second arts jobs (an annual average of 10.7 hours per week), than those with artistic primary jobs (12.1 hours per week). In total, those who were not working as artists in their primary jobs worked more hours than those who were artists in their primary jobs. This finding is consistent with observations made earlier that artists work fewer hours in their primary job (whether moonlighters or not) than other professionals.

Perhaps the difference in the amount of time spent working on second jobs between the two groups can be explained by the artists' stated reasons for working at second jobs. Information on why workers held artistic second jobs is available only for the years 1985, 1989, and 1991. In 1991, one of the major differences between these two groups of artists lies in the percentage that indicated they worked at their second jobs because they "enjoyed" them.[5] Persons who worked as artists in second jobs but held primary jobs outside the arts indicated that they worked at their second (arts) jobs because they "enjoyed" them nearly twice as often as did primary job artists with non-artistic second jobs; the difference in the "enjoyment" frequency for the second job was 45 percent versus 23 percent.

In 1985 and 1989 the CPS did not provide multiple jobholders with the choice of "enjoy" as a reason for holding a second job. It did permit the multiple

5. The only year in which the information on a second occupation allowed the identification of artists' second jobs and where they were able to select "enjoy" as a reason for working at a second job was 1991.

jobholder to choose "obtain an experience that differed from the primary job" as a reason for moonlighting. In 1989, second job artists were twice as likely to select this reason to explain their multiple jobholding than primary job artists (28 percent compared to 14 percent). However, in 1985, both groups chose this reason with roughly equal frequency.

In all three years there was a considerable difference between the two groups of artists in the proportion indicating that they held second jobs because they "needed to work to meet their households' regular expenses." In 1991, the proportion of primary job artists who indicated that they were working at their second jobs because they "needed additional earnings to cover household expenses" was greater than twice that of second job artists. The difference was 34 percent versus 15 percent. In 1989 the proportion of primary job artists who identified this reason was twice the proportion of secondary job artists: 46 percent versus 23 percent, respectively. In 1985 the difference was not as extreme: 33 percent versus 22 percent.

This evidence indicates that artistic second jobs are often pursued because of the pleasure they give or because of the interesting experiences they provide. They are pursued less often because of the help they provide in enhancing income. Although, based on this information, it is tempting to treat artists' second jobs as "avocations," evidence from direct surveys of artists indicates that even secondary job artists often identify more closely with their artistic jobs. On the other hand, primary job artists chose supplementing their income as the most likely reason for holding a second job outside the arts, a justification more consistent with the "hours constraint" theory of multiple jobholding.

Reasons for Multiple Jobholding

The reasons for holding more than one job at a time can be as varied as the number of jobs being held. During some of the twenty-seven year period covered in this report, as already seen, the CPS asked the people who held second jobs to indicate their reasons for doing so. This section will examine the reasons given for holding more than one job at a time by those with artistic primary occupations and compare them to the reasons given by the non-artist professionals who were multiple jobholders.

The most frequent explanation provided by artists for holding multiple jobs was that they needed the additional earnings generated by the second jobs to meet their households' regular expenses (Chart 3.17). This was also the most frequent explanation given by other professionals in all but three of the years (Chart 3.18). An average of almost one-third of the multiple jobholding artists

in this period identified meeting regular expenses as their reason for a second job, while only about one-quarter of the multiple jobholding professionals selected it as their reason for working at second jobs.

Enjoying the work they were doing on the second job was the second most frequently identified reason for being a multiple jobholder by artists for most years. In two of the years it was the most frequently cited explanation. The same was true for professional workers who were multiple jobholders. There was little difference between the percentage of artists and the percentage of professional workers who indicated this was the reason for holding a second job.

The desire to obtain a different experience than what they were getting at their primary jobs was the third most common explanation for multiple jobholding among the artists. This was the case for almost all the survey years. The same was true for the multiple jobholding professional workers, but in fewer of the survey years. Additionally, the percentages of artists and professional workers identifying this reason for being multiple jobholders were approximately the same.

The frequencies with which the artists chose the remaining explanations for multiple jobholding over this period did not follow as clear a pattern. The general pattern for the remaining three reasons was essentially the same for both the artists and the other professional workers. The need for extra money was the next most commonly cited explanation. This was then followed, quite closely, by both the desire to earn some money to put into savings, and to earn some money to pay off some already existing debts.

Not surprisingly, the reasons for the artists' multiple jobholding behavior are not the same across all types of artists (Appendix Charts A–3.13 to A–3.16). Visual artists were most likely to have indicated that the need to cover their households' regular expenses was their reason for holding second jobs. An average of almost forty percent of the visual artists identified this reason over the period. They were the least likely of the artists to have indicated that they were doing so because they enjoyed working at their second jobs. Only about twelve percent identified this as a reason for having held a second job.

Architects and designers were the least likely to have identified the need to cover the households' regular expenses as the reason for holding their second jobs. Less than twenty percent, on average, cited this reason. They were the most likely artists to be holding their second jobs to gain a different experience than what they were getting on their primary jobs. This was the reason cited by approximately one-quarter of the architects and designers. In fact, architects and designers cited the need to cover expenses as a reason for holding second jobs less frequently than the other professionals who were multiple jobholders cited it.

It was the artists who comprise the "other" artists group who were most likely to have indicated that they were multiple jobholders because of the enjoyment they received from their second jobs. This reason was cited, on average, by slightly more than thirty percent of the artists in this group. This group of artists was also the least likely to have been working at second jobs because they wanted an experience that differed from what they were getting on their primary job. It was a reason cited by less than six percent of the multiple jobholding artists in this group.

Multiple jobholding performing artists were the second most likely, after the visual artists, to have indicated that they worked at their second jobs because they found the work to be enjoyable. An average of more than one-third of the performers indicated this was why they worked at second jobs. The performers were among the least likely of artists to indicate that they held second jobs to help pay off their debts. Fewer than four percent of the performers and the artists in the "other" artists group indicated this was the reason for working at a second job.

Second Jobs Held by Artists

Since artists indicate that they hold second jobs because they need the additional income, the question of how artists accomplish this can be partially answered by looking at the types of second jobs held by the multiple jobholding artists. Over this twenty-seven year period there appear to have been some significant changes in the types of second jobs they held. Also, some of what they do in second jobs may be contrary to the stereotypes of artists, such as driving taxis or waiting on tables. This section will provide a brief examination of some characteristics of the second jobs held by artists.

The most common type of second job held by artists over this period was one among the professional and technical occupations (Chart 3.19). In fact, over this period between 55 percent and 75 percent of the artists with second jobs had professional or technical jobs as their second jobs. It is important to note that the arts occupations are included among the professional and technical occupations. It was not possible for much of the study period to separately identify the arts occupations among the other professional and technical occupations for the second jobs. Therefore, much of the multiple jobholding may actually involve artists working in second arts occupations; for example, an professor of art at a college or university who identifies his/her second job as painter (visual artist).

From 1985 (when greater detail became available on the occupation of the second jobs) through 1997 there apparently was a considerable change in the proportion of artists whose second occupations were also in arts occupations. In 1985, 60 percent of the artists' second jobs were in artistic occupations. By the mid to late '90s the proportion with second artistic occupations settled at around one-third. The annual average over this period was almost 40 percent holding second arts jobs. Over the same period there was a considerable growth in the proportion of artists working in the other professional, managerial and technical occupations, from approximately 13 percent in 1985 to slightly more than 31 percent in 1996. In 1997 the proportion was somewhat lower. There was also growth in the proportion of artists who worked as sales workers, clerical workers and service workers for their second jobs. In 1985 approximately 15 percent of multiple jobholding artists worked in these occupations and by 1997 slightly more than one-quarter worked in them. Throughout the twenty-seven year period the sales, clerical and service jobs rarely counted for less than 20 percent of the artists' second jobs. In fact, the annual average was 19 percent for artists compared to 24 percent for the other professional workers who held second jobs.

There were considerable differences among artists' primary arts occupations in the proportion of artists whose second occupation was also an artistic one (Appendix Charts A–3.17 to A–3.20). Over the 1985 to 1997 period, multiple jobholding visual artists were by far the most likely to work at second arts occupations. On average, each year almost 47 percent of the multiple jobholding visual artists worked a second job in an artistic occupation. The artists least likely to be working at a second job in an artistic occupation were the performers. On average a little more than 33 percent of them worked in a second artistic occupation. The behavior of the "other" artists was very much like the performers, with an annual average of 35 percent also working in a second artistic occupation. With an average participation rate of 40 percent, architects and designers were somewhat more likely to have a second job in the arts. It is interesting to note that an average of more than 6 percent of the other professional workers who were multiple jobholders held second jobs in the arts (Chart 3.20).

There are also differences among artists' primary arts occupations in the likelihood of holding their second jobs in the sales, clerical and service occupations. The differences in the annual average proportion of artists holding second jobs in these occupations are not as large as for those holding second artistic occupations. Architects and designers were the most likely to have second jobs in one of these occupations. On average more than 26 percent of architects and

designers holding second jobs worked in one of these occupations. The artists in the "other" category were the least likely, with an annual average of just under 17 percent. A somewhat surprising finding is that performers held slightly less than 20 percent of their second jobs in the sales, clerical and services occupations. These occupations include the stereotypical second jobs thought to be held by performers, including waiting on tables. On average, almost one-quarter of the visual artists with second jobs worked in one of these occupations.

To obtain a better understanding of artists' multiple jobholding behavior, it is also important to examine where they held their second jobs. One dimension of this question is the nature of employment: for example, public versus private employment, and working for an employer or self-employed. An examination of the work environment finds that on their second jobs, moonlighting artists were most likely to have worked in the private sector as employees of businesses, both for profit and non-profit (Chart 3.21). Depending on the year, the proportion with second jobs working for firms in the private sector ranged from 40 percent to as high as 65 percent, with an annual average of 51 percent of the jobs being held there. Being self-employed in some income-earning activity was the second most likely venue for the multiple jobholding artists. The proportion of self-employed artists ranged from 22 percent to 50 percent over the twenty-seven year period, with an average of 39 percent self-employed annually.

The least likely place for artists to hold their second jobs was in the government sector. From 7 percent to 18 percent of moonlighting artists held second jobs working for the federal, state, or local governments over the twenty-seven year period, with an annual average of 11 percent. On average, compared to other professionals who were multiple jobholders (Chart 3.22), multiple jobholding artists were equally likely to have their second jobs in the private sector (51 percent versus 49 percent). They were slightly more likely to be self-employed (39 percent versus 31 percent) than other professionals. They were also considerably less likely to be working in the government sector (11 percent versus 20 percent) than other professionals.

A closer examination of the nature of employment for the second job suggests that one group of artists, the performers, differs considerably from their artistic colleagues in where they found their second jobs (Appendix Charts A–3.21 to A–3.24). Multiple jobholding performers were much more likely to have held second jobs in the private sector than any other moonlighting artists. Sixty-two percent of them, on average, worked in the private sector; while the average for all the other artists was less than half for the twenty-seven year period (42 percent for architects and designers, 46 percent for visual artists, and

48 percent for other artists). As a result, performers were much less likely, to be self-employed on their second jobs than their colleagues (27 percent as compared to 49 percent for architects and designers, 43 percent for visual artists and 36 percent for other artists). Performers were not that different relative to all other artists in their likelihood of employment in the government sector, with slightly more than eight percent having held second jobs there. It was the other artists group who were most likely to have held second jobs in the government sector, with more than 16 percent having done so compared to 10 percent of architects and designers and 11 percent of visual artists.

Another way of parsing the context of artists' second jobs is to examine the industries in which these jobs are held. The most common industry of employment for second jobs of both artists and other professionals was the "professional services" industry (Chart 3.23). More than one-third of both groups, on average, held jobs in this industry (36 percent of the artists and 38 percent of the other professionals). This reflects the fact that the Census defines self-employed artists as working in the "professional services" industry along with self-employed lawyers, doctors, and other professionals. Artists differed from their professional peers (Chart 3.24) throughout the period by being more than twice as likely to hold their second jobs in the entertainment industry (12.4 percent versus 5.4 percent), and being more likely to have second jobs in the service industry than their professional peers (18 percent versus 14 percent). To artists, service jobs not only provide flexible work to fill in gaps in an artistic career, but represent a growth area in the economy. A larger difference is found in the proportion of artists working in the wholesale trade, retail trade, finance, insurance and real estate industries. The non-artist professional workers were one-third more likely to have worked in these industries than their artist peers (22 percent versus 16 percent).

Within the artistic professions there exists considerable, though not as large, differences in the industry of employment for the second jobs (Appendix Charts A–3.25 to A–3.28). The largest difference is in the likelihood of employment in the service industries. Visual artists were almost three times as likely, on average, to have worked in the service industries than other artists (31 percent versus 11 percent) and more than twice as likely than performing artists (15 percent). Only about 13 percent of architects and designers and visual artists had second jobs in the entertainment industry, but almost 20 percent of other artists and almost one-quarter of performing artists held second jobs in this industry. The other differences that existed in the rate of employment in a second industry were not as large across the artistic occupations. The remaining major difference is working in the "professional services" industry when comparing

performing artists to other artists. The other artists were considerably more likely to have worked in this industry (48 percent) than the performers (28 percent). There was essentially no difference in the likelihood of architects and designers and visual artists in working in this industry. There is relatively little difference in the likelihood of different types of artist working in the manufacturing, communications, or public utilities industries.

Multiple Jobholding Artists: Detailed Demographics

The characteristics of artists who were multiple jobholders varied over the twenty-seven year period, in some cases by type of artist, or over time, and sometimes by both aspects. What follows is an examination of differences in the age, schooling, gender distribution, racial distribution, geographic distribution, and marital status of the artists who were multiple jobholders. There will also be a comparison to the non-multiple jobholding artists.

By Gender

The average proportion of multiple jobholding artists who were men ranged from almost 63 percent for other artists to almost 72 percent for architects and designers. Among single jobholding artists, a greater difference exists across types of artist in the proportion of men. This is primarily due to a significantly smaller proportion of men among the other artists group for the single jobholders (55 percent versus 70 percent for architects and about 65 percent for all others). Over the 27-year period, there was a significant increase in the proportion of women among both the multiple and non-multiple jobholding artists in all but the performing artist group (Chart 3.25). The proportion of multiple jobholding architects and designers who were women increased from almost zero in 1970 to more than half in 1997. For non-multiple jobholding architects and designers the change was also dramatic; the percent women went from about 15 in 1970 to 50 in 1997. The period of the most dramatic change appears to have been the early 1980s for both groups of architects and designers. Between 1980 and 1985 the proportion of multiple jobholding architects and designers who were women almost tripled; over the same period the proportion of women among non-multiple jobholders in these occupations more than doubled. Changes for the visual and other artists in both groups were not as great.

By Race

Over time, multiple jobholding artists differed less by race than they did by gender (Chart 3.26). The proportion of white artists ranged from almost 93 per-

cent for performing artists to almost 96 percent for visual artists. While the proportion white tended to decrease over time for all artist groups, the decline was only significant among performers. In 1970 the proportion of moonlighting performers who were white was greater than 98 percent; by 1997 the proportion had decreased to approximately 86 percent.

The racial composition of non-multiple jobholding artists was more diverse than that of their multiple jobholding colleagues. The differences in the proportion white over the period were significant across the four artist groups. The percentage of whites ranged from just under 90 for performing artists to almost 95 for visual artists. The racial diversity of all four groups of non-multiple jobholding artists increased significantly over the twenty-seven years. The biggest change was among visual artists, where the proportion of whites decreased by more than eight percent over the period. The smallest change was among architects and designers, with a decrease of approximately five percent in the proportion of whites. Both performing and other artists had decreases of about seven percent.

It is not clear why minority artists moonlight less frequently than white artists. Evidence for the entire labor force examined in Chapter 2 also revealed that minorities were less likely to moonlight than whites. Artists are no different in this respect.

By Educational Attainment

Over the 1970 to 1991 period, there was a significant difference between the amount of formal schooling (primary, secondary and college) completed by multiple jobholding artists (Chart 3.27) and by artists without second jobs. (Because of changes in the Census methodology, years of schooling cannot be estimated after 1991.) Multiple jobholding visual artists had the least amount of formal education, with slightly more than 14 years of schooling. Visual artists without second jobs also averaged the least schooling among artists without second jobs. They were marginally less educated than their multiple jobholding colleagues. Multiple jobholding performing artists completed more schooling than visual artists, averaging just under 15 years. Non-multiple jobholding performers averaged less than their multiple jobholding colleagues, with just under 14 years of formal schooling. Both multiple jobholding and non multiple jobholding architects and designers averaged more schooling—15.7 years—than their performing arts and visual arts colleagues. Multiple jobholding other artists were the most highly educated, averaging 16.5 years of schooling. Among the artists in the other artist group are the post-secondary teachers of art, music and drama.

There also was significant growth in the amount of formal schooling completed by multiple jobholding performing and visual artists over this period. The average amount of schooling completed by performing artists rose from 13.3 years in 1971 to 15.3 years in 1991. Years of schooling for visual artists rose from 12.6 years in 1970 to 14.1 years in 1991. Increases in years of school also occurred among non-multiple jobholding visual artists and other artists over this period.

By Age

The average age of the multiple (Chart 3.28) and non-multiple jobholding artists varied significantly with type of artist and, in some cases, increased over time. Performing artists, whether multiple jobholders or not, were the youngest. The average age of those with second jobs was 35.3 years; of those without second jobs it was 34.5 years. Both types of other artists were by far the oldest. At 38.7 years, the age of multiple jobholding other artists was two years greater than their visual artist colleagues, the next oldest group. For other artists without second jobs, the difference between them and their visual artist colleagues was almost three years (41.5 versus 38.6 respectively). Multiple jobholding architects and designers were three years younger than their non-multiple jobholding colleagues (36.1 versus 39.2 years old). Both multiple jobholding architects and designers and visual artists had significant increases in average ages for the period, as did non-multiple jobholding other artists.

By Marital Status

The discussion of the marital status of multiple jobholding artists is limited to the 1989–1997 period (Chart 3.29). Prior to 1989, people who were separated but not divorced were considered by the CPS to be married, but during the 1989–97 period they were included with those who were widowed and divorced. The latter appears to be a more appropriate classification from an economic perspective.

Married artists comprised the largest group regardless of the artist type. Throughout the period, non-multiple jobholders were more likely to be married than their multiple jobholder counterparts. This no doubt reflects the importance of the alternative of economic support provided by the artist's spouse. With the exception of performing artists, more than half the artists were married during this period (Appendix Charts A–3.29 to A–3.32). Performing artists, being the youngest, were the most likely to have never married. Regardless of the type of artist, the proportion who were widowed, separated or divorced was the smallest; it ranged from 12 percent for the multiple jobholding architects and designers,

and for performers, to almost 16 percent for multiple jobholding visual artists. The percentage of widowed, separated or divorced non-multiple jobholding artists ranged from 12 percent for architects and designers to 16 percent for other artists.

By Region

In some cases, the geographic distribution of the artists is likely to reflect relative market conditions for the artists' primary income earnings activity, their art. In others, it may simply reflect the distribution of artists' residences. However, aggregating place of residence to just four regions may blur such distinctions (Chart 3.30). Nevertheless, we observe some differences.

There was a somewhat greater concentration of multiple jobholding architects and designers in the midwest, where an average of 31 percent of them resided, versus 25 percent in the south and approximately 28 percent in both the northeast and west (Appendix Charts A–3.33 to A–3.36). There was a greater concentration of non-multiple jobholding architects and designers in the northeast (30 percent on average), with the smallest shares in the midwest and west (an average of approximately 22 percent). Multiple jobholding performing artists were relatively evenly distributed across the four regions. Non-multiple jobholding performing artists were less equally distributed, being concentrated in the south (an average of 30 percent) and the west (almost 28 percent), but not in the midwest or northeast (20 percent). Visual artists multiple jobholders were more concentrated in the west (almost 30 percent) and least concentrated in the northeast (21 percent). The midwest and the south again had almost equal proportions, around 26 percent each. An average of almost 23 percent of the multiple jobholding other artists lived in the midwest, with 26 percent in both the northeast and the west, and 29 percent in the south over this twenty-seven year period. Both the non-multiple jobholding visual and other artists were, on average, evenly distributed across the four regions of the country.

Direct Surveys of U.S. Artists

Information on artists' multiple jobholding from the CPS and the Census is limited in several important ways. Various direct surveys of artists undertaken in this country provide additional information not available through the CPS and the Census. In some cases this includes information on multiple jobholding. This section will examine the findings from these surveys on artists' multiple jobholding behavior. First to be discussed is how the information in the Census and the direct artist surveys can be viewed as complementary.

The Census and CPS Methodology

The CPS and Census data are limited by the aggregation of artistic occupations into eleven artistic groups making it difficult, if not impossible, to develop a full understanding of the nuances of the various artistic occupations that multiple jobholding artists simultaneously hold. For example, the CPS can identify an artist who is both a musician and a novelist or a musician and a dentist, since these occupations fall into two distinct CPS occupational groups. However, it cannot identify the artist who works as both a painter and a sculptor since it identifies both occupations as part of the visual artist group. A direct survey of artists can utilize more specific and narrow occupational definitions to explore multiple jobholding behavior more comprehensively.

The CPS information, like that of the Census, is based on the artist's chief job or business activity in the week prior to the survey week. Thus it does not identify any work activity that the artist may have participated in at other times of the year. As noted in Chapter 2, the number of artists identified as multiple jobholders during the week the survey is taken is likely to be less than the number of artists who hold multiple jobs during the year, either simultaneously or sequentially. Virtually all of the artist surveys ask questions about jobs held throughout an entire year, not a reference week.

Further, neither the CPS nor the Census considers a person who is self-employed to be a multiple jobholder if his/her second work activity is also as a self-employed worker (Stinson, 1997, 3). Therefore, a self-employed painter and photographer is not categorized as a multiple jobholder. If the same person painted and worked as a photographer for a newspaper, this artist would count as a multiple jobholder according to the CPS. Finally, the CPS only collects information on one additional job. If a person actually holds more than two jobs simultaneously or over a period of time, this would not be identified in the data. The case of a musician who performed at a club in the evening, drove a taxi in the morning, and was a cashier at K-Mart in the afternoon, all during the same week, would not be fully documented in the CPS.

Direct Survey Methodology

Direct surveys of artists possess other more generalized differences from the Census/CPS methodology. First, they have been administered by researchers looking to collect specific information about artists. Thus they are not limited by the problem of designing a questionnaire that applies to all types of worker. Second, sample selection is usually quite different. These surveys may be aimed at a particular group of artists (performers who are union members, e.g.), in

which case no attempt is made to draw a random sample. Alternatively, the sample base may be broad but a lack of knowledge of the entire population may render it impossible to make random selections from the population. As a consequence, conclusions drawn from the survey results, though they may be valid, cannot be as easily generalized to the entire artist population.

Another important implication of the sampling methodology is that the vast majority of persons in direct artist surveys self-identify as artists. In the Census and CPS, any person in the labor force is assigned to the occupation in which he or she spent the most time working in the reference week. For example, this leads to classifying as a courier an unemployed actor who delivers messages in the reference week. In a direct survey in which artists self-identify, this person would more likely declare to be, and be classified as, an actor.[6]

A Review of Direct Surveys of Artists

A survey of artists in New England undertaken in the early 1980s (Wassall, et al, 1983) provides detailed information on artists' multiple jobholding behavior for an entire year rather than for one week during the year. This study also used a more narrow definition of the artist occupation; the categories used can be seen in Table 3–1. Artists were asked to distinguish among three types of jobs that they may have held during the year. These were: artist; arts-related, such as arts teacher or as arts administrator; and non arts-related, such as courier or salesperson.[7] Depending on the specific artistic occupation, 10.8 to 37.1 percent of the surveyed artists indicated that they had worked solely as artists during the year (Wassall, et. al., 1983, Tables 7, 32). The remainder indicated that they had held either an arts-related job or a non arts-related job or both at some time during the year. As a consequence the rate of multiple jobholding for these New England artists was considerably greater over the entire year than it would have been in any particular month of the year.

Consistent with the findings of the CPS data, multiple jobholding when viewed on an annual basis also differed with the type of artist. Those artists who were most likely to work outside their artistic occupations during the year were choreographers, composers and playwrights (90 percent), musicians (86 percent), dancers (84 percent), and writers and poets (84 percent). Those most

6. For example, in the New England artist survey discussed immediately below, 74.1 percent of those surveyed declared artist as their "principal profession," even though 52.6 percent had zero or negative net artistic income (i.e., income after deducting the expenses of earning that income), and only 24.1 percent held no non-artistic job during the survey year, (Wassall and Alper, 1985). The debate over whether one's occupation is defined by what one does or what one claims to be perhaps can never be resolved.

7. Thus some occupations defined as artistic in the NEA classification scheme (art, drama and music teachers, e.g.) were defined as arts-related in this survey.

likely to work only as artists and hold no other jobs during the year were visual artists (27 percent), craft artists (34 percent) and actors (37 percent).

More than half (55 percent) of the New England artists had held an arts-related job at some time during the year. Choreographers, composers, and playwrights were the most likely to have held arts-related jobs (almost 80 percent). Two-thirds of the dancers and musicians also spent time doing arts-related work. The actors and the crafts artists were the least likely to have done this type of work, approximately 40 percent of both groups did so. The vast majority, almost 80 percent (Wassall, et. al. 1983, Table 8, 34) of the artists who did arts-related work taught their art. This could have been in a formal school environment or by providing private lessons. Almost ten percent worked in arts management, and six percent had other professional and technical jobs in the arts.

Slightly more than one-third (36 percent) the New England artists worked in non arts-related jobs. The writers were the most likely to have held such jobs, with 44 percent having done so, while dancers and actors were only slightly less likely to have held non arts-related jobs (41 and 40 percent respectively). Approximately one-third the musicians, visual artists, and craft artists held non arts-related jobs. The choreographers, composers, and playwrights were the least likely with only 28 percent having non arts-related work, probably because most of them were already working in arts-related jobs along with their art work. The primary occupation for these jobs was not waiting on tables, only 14 percent of the non arts-related jobs were service jobs, nor was it driving a cab, only five percent held operative jobs. The most commonly held non arts-related occupations were non teaching professional and technical occupations, with almost 20 percent of those having held a non arts-related job having one of these. Non arts teaching was the next most likely occupation to be held by the artists (15 percent), with clerical work next (13 percent). Sales and managerial jobs were each held by approximately eleven percent of the artists who worked at a non arts-related job.

Because so many artists worked outside their artistic occupations, the survey probed for reasons for moonlighting. Artists were permitted to choose as many reasons as applied to their situations. Not surprisingly, and consistent with the CPS findings, the primary reasons that the New England artists gave for taking on extra jobs were economic (Wassall, et. al., 1983, Table 11, 37). More than 60 percent indicated they worked outside their art because the work paid better. Almost half also indicated that the non-arts jobs provided better job security than their arts jobs, and half also indicated that they took on this other work

because there was not enough work available in their artistic fields.[8] A very small proportion of artists indicated that they actually preferred their non-arts work to their arts work (approximately four percent), while almost 40 percent indicated that they worked outside their art because they felt it complemented their work as artists.

The evidence from the New England survey on simultaneous multiple job-holding is consistent with the CPS. An examination of the average number of weeks worked by the New England artists in each type of job provides indirect evidence to support this explanation (Wassall, et. al., 1983, Table 13, 39). On average artists reported working 36 weeks in their art, 17 weeks in jobs related to their art, and almost 12 weeks in other, non-arts related jobs. The only way the total number of weeks worked in all these jobs combined can average 66 weeks is through concurrent multiple jobholding. The evidence is even stronger when simply looking at those artists who actually worked outside their artistic occupations. Artists who held arts-related jobs averaged almost 33 weeks working at these jobs, and those who held non arts-related jobs spent an equal amount of time working at them. Again, this can only occur by simultaneously holding more than one job.

The importance of all these work activities on the artists' economic well-being is best examined by looking at their contributions to the artist's income. Consistent with the reasons for holding more than one job cited by the CPS and this survey, the arts-related and non arts-related work undertaken by artists were important components of their total income (Table 3.1). On average, earnings from these second jobs accounted for almost half the artists' total income (48.9 percent). Working as an artist contributed about 40 percent, with the remaining 10 percent from non-labor sources such as Social Security, investments, and welfare. Interestingly, among the artists in the 1981 survey, actors earned the largest share of their income from working in their art, approximately 70 percent. Actors also were the artists for who arts-related earnings accounted for the smallest share of their income, approximately seven percent. For choreographers, composers, and playwrights it was the reverse. Their work in their art form accounted for the smallest share of income among all the artists surveyed, only 22 percent, while their arts-related earnings contributed the most, almost 60 percent. Of all the artists it was actors and theater production personnel who earned the smallest share of their income from non arts-related work, approximately 11 percent. The dancers were the artists who earned the

8. Unlike the CPS, in the New England study artists were able to identify more than one reason for having a second job.

largest share of their income from non arts-related jobs. Earnings from this type of work accounted for almost 26 percent of their total income, more than double the contribution of the actors' work in non arts-related employment.

Another work related characteristic of artists is that many work in a variety of artistic occupations. For example there are painters who sculpt, actors who write, and dancers who also work as choreographers. Many of the artists in the New England survey indicated that they had a second artistic occupation (Wassall, et. al., 1983, Table A-3, 184). Musicians were the most likely to have identified a second artistic occupation, with almost three-quarters indicating they did, while the crafts artists were the least likely, with only one-third indicating that they had a second artistic occupation. For dancers the most common second occupation was that of choreographer, 38 percent of the dancers listed choreography as their second occupation, and the second most common, identified by 10 percent of the dancers, was a second dance form. An almost equal number of dancers identified their second occupation as musician, actor, or visual artist, with almost five percent in each occupation. Almost 60 percent of musicians listed a second musical occupation, while an additional seven percent identified composing. Two of the significant second occupations for actors were working in theater production (14 percent) and writing (seven percent). Writers and poets were often involved in more than one writing activity (almost 30 percent), and five percent were also involved in the visual arts. Those who identified themselves primarily as choreographers, composers, and playwrights were also musicians (22 percent), dancers (12 percent), involved in theater production (11 percent), and were actors (7 percent). Many of the visual artists worked in more than one visual art form (27 percent) while others worked as craft artists as well (9 percent). The most common second occupation for the craft artists was the visual arts (16 percent), but there were also craft artists who were writers (almost three percent).

An update of the New England study was recently undertaken, but only for the state of Rhode Island (Alper and Galligan, 1999). The survey obtained responses from over 400 artists residing in Rhode Island and the information obtained was for 1997. Like the previous study, this one also found that the majority of the state's artists (55 percent) worked at some income generating activity other than their art at some point during the year. A little more than 45 percent held an arts-related job at some time, and almost 30 percent held a non arts-related job. The evidence for simultaneous multiple jobholding again comes from the number of weeks worked at the three labor market activities and supports the previous study's finding of significant simultaneous multiple

jobholding behavior among Rhode Island's artists in 1997. On average the state's artists worked 40 weeks in their art, 19 weeks in arts-related activities, and 13 weeks in non arts-related work (Alper and Galligan, 1999, Table 8). The evidence suggests that the dancers and choreographers (a single group in this study) were the most likely to have been simultaneous multiple jobholders since the total average number of weeks worked during the years was the highest for them. They were followed by the writers, musicians, craft artists, visual artists, media artists, and the actors in decreasing order of the likelihood of multiple jobholding.

Rhode Island's artists, like the artists in New England seventeen years earlier, found the earnings from their second jobs to be a very important component of their total income. On average Rhode Island's artists earned half their income (50.4 percent) from their arts-related and non arts-related jobs. Arts-related work was the most important of these second jobs accounting for almost one-third their income (30.0 percent) while non arts-related work contributed an additional 20.4 percent to total income. Work as an artist contributed, on average, 45 percent of the artists' income with the remainder accounted for by non labor income.

There is also evidence from the Rhode Island survey that artists' responses to economic incentives for having a second job is consistent with theory and studies of non artists. In 1997, Rhode Island's artists had an hourly wage rate of $22.74, on average, from working in their art (Table 3.2). The estimated hourly wage rate for arts-related work was $29.30, or almost 30 percent higher than their wage from working as artists. This second job wage premium is important in understanding why artists are multiple jobholders. The higher wage in the arts-related work represents an opportunity cost to the artists for working in their art. The higher it gets, the less time the artists are likely to spend at their art. In fact for all the artists in this survey, with the exception of the musicians and the actors (the other artist groups are: dancers, writers, visual artists, media artists and craft artists), the estimated arts-related wage was greater than the wage from their art work. The incentive to work outside their art form at an arts-related job was greatest for the writers. Their hourly wage on their arts-related work was estimated to be seven times greater than their arts wage. The opportunity cost explanation for holding a second job is not as well supported for non arts-related work. The estimated wage from non arts-related work was $18.04, almost $5 per hour less than from working as an artist. Perhaps there are other reasons for holding these jobs that explains why so many artists also have non arts-related work during the year. The other factors could include things such as health insurance, pensions, and other forms of non-monetary compensation that are readily available from an employer. The estimated non

arts-related wage was greater than the arts wage for dancers, writers and media artists. It was not greater than the arts-related wage for any of the artist groups.

In 1980 a special survey of authors was undertaken for the Authors Guild (Kingston and Cole, 1986). This survey, Columbia Survey of American Authors, like other specialized surveys of artists, found that approximately 70 percent of the authors surveyed had income from work other than their writing. Almost half (46 percent) held salaried positions in addition to writing, and almost 40 percent without regular non-writing positions worked as writers and in writing related jobs such as translating and editing.

Another survey of artists was undertaken in 1989 for eight cities and two areas throughout the United States by the Research Center for Arts and Culture at Columbia University (Jeffri, 1989). It, too, found that multiple jobholding was common among the artists surveyed. The multiple jobholding rate for the surveyed writers was approximately 50 percent (Alper, et al, 1996, Table 25, 50).

A survey of performing artists was undertaken in the early 1980s (Ruttenberg, Friedman, Kilgallon & Associates, 1981). It, like all the other studies, found a significant amount of performers holding second jobs, regardless of whether they were actors, singers, dancers or musicians. The differences they found were in where the performers were likely to hold their second jobs. More than half the actors and singers worked in sales, clerical or service jobs, while approximately one-fourth the musicians and one-third the dancers held similar jobs (Kay and Butcher, 1996, 102).

A more recent survey of choreographers (Netzer and Parker, 1993) reported that 80 percent of these artists held jobs in addition to their choreographer work during the reference year.[9] Further, they spent twice as much time working in their non-choreographer jobs. Last, earnings from their choreography work constituted from 14.7 to 30.6 percent of their total earnings, depending on the city in which they worked.

In summary, direct surveys of artists have not measured the extent to which artists hold multiple jobs in the same week, but have measured the extent to which artists hold jobs in different occupations over the course of a year. They have also documented the importance of non-artist jobs in artists' annual earnings. It is clear that many, perhaps most, artists rely heavily on income from non-artist jobs in a typical year. Thus surveys, such as the Census, which attribute all income to a person's "principal job" in a reference week very likely overstate the financial returns to being an artist.

9. It is not indicated whether these jobs were exclusively in non-artistic occupations.

Table 3.1
Sources of Artists' Income
(percent)*

	Arts Earnings	Arts-Related Earnings	Non Arts-Related Earnings
All Artists	41.0	30.3	18.6
Dancers	45.9	28.1	25.7
Musicians	38.1	35.4	20.8
Actors	70.8	7.4	11.0
Theater Production Personnel	48.9	32.3	10.7
Writers and Poets	23.9	35.3	25.3
Choreographers, Composers, and Playwrights	21.9	58.2	12.1
Visual Artists	41.4	31.8	16.8
Media Artists	47.9	18.9	21.8
Craft Artists	48.1	22.1	18.7

*Rows are a percent of total income and do not sum to 100% because of non-labor income.
Source: Authors' calculations from Wassall, et. al., 1983, Table 22, 55.

Table 3.2
Rhode Island Artists'
Hourly Earnings by Occupation: 1997

	Art Wage	Art-Related Wage	Non Art-Related Wage
All Artists	$22.74	$29.30	$18.04
Dancers	$26.37	$45.42	$32.04
Musicians	$27.69	$21.13	$15.49
Actors	$32.49	$25.38	$14.25
Writers	$4.47	$30.71	$18.20
Visual Artists	$27.16	$32.85	$19.55
Media Artists	$13.84	$22.06	$21.24
Craft Artists	$16.65	$31.07	$11.84

Source: Alper and Galligan, 1999, Table 10.

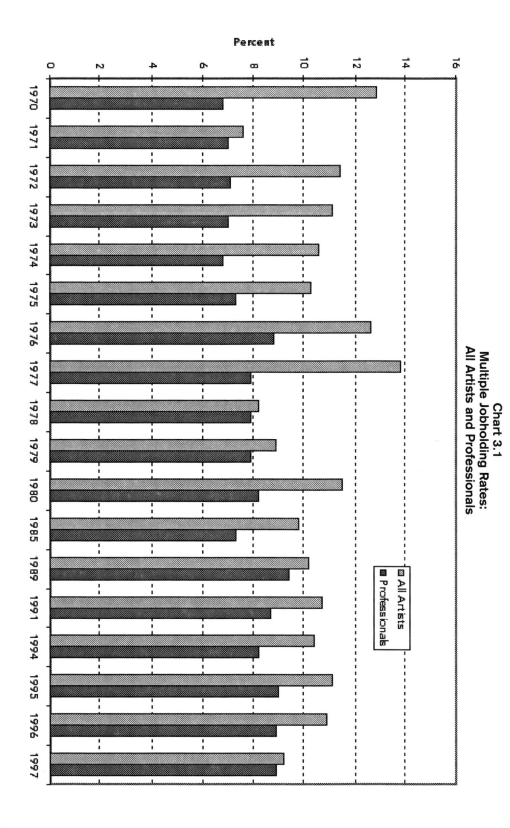

Chart 3.1
Multiple Jobholding Rates:
All Artists and Professionals

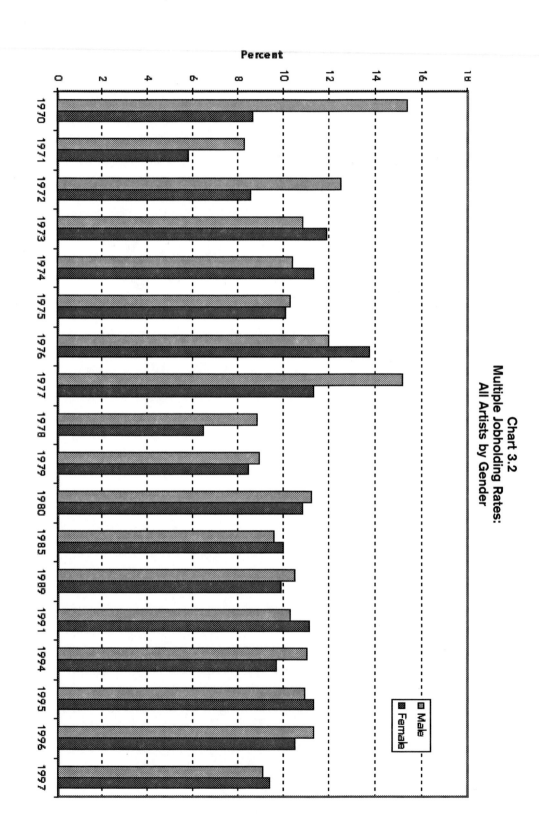

Chart 3.2
Multiple Jobholding Rates:
All Artists by Gender

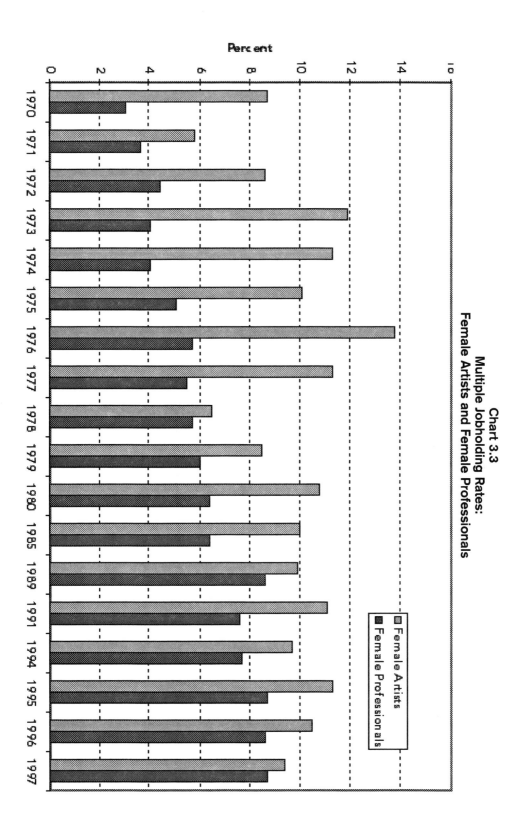

Chart 3.3
Multiple Jobholding Rates:
Female Artists and Female Professionals

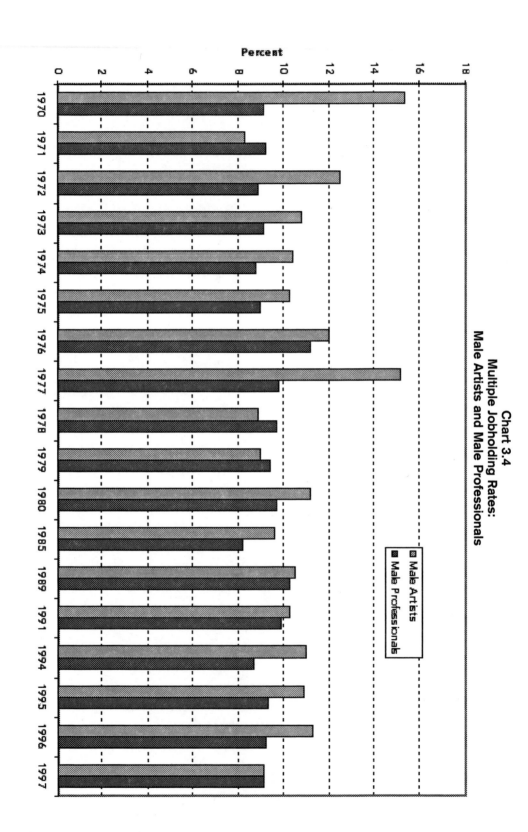

Chart 3.4
Multiple Jobholding Rates:
Male Artists and Male Professionals

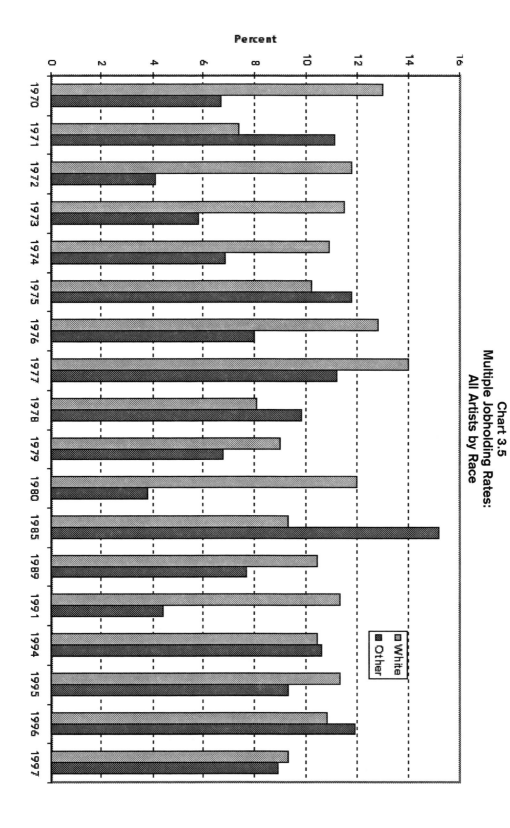

Chart 3.5
Multiple Jobholding Rates:
All Artists by Race

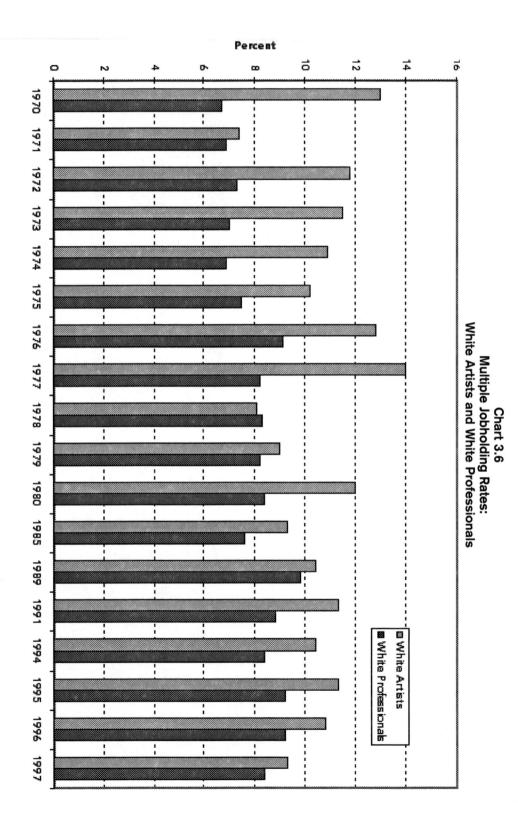

Chart 3.6
Multiple Jobholding Rates:
White Artists and White Professionals

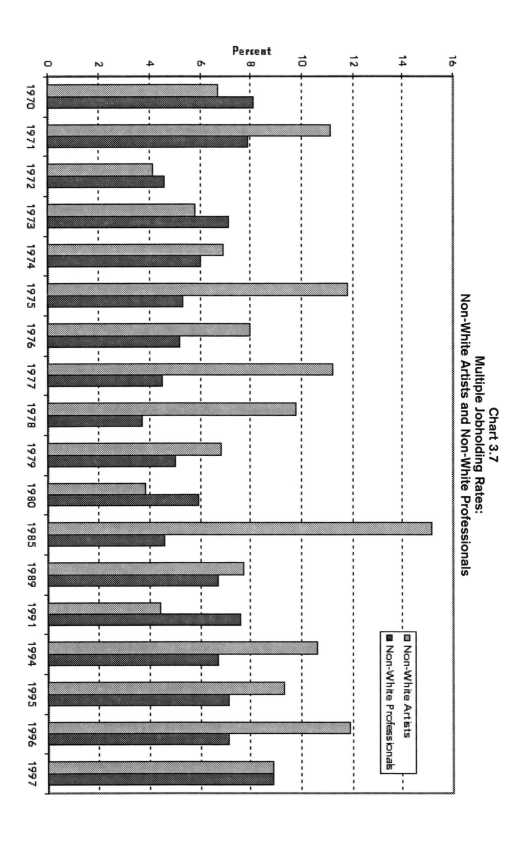

Chart 3.7
Multiple Jobholding Rates:
Non-White Artists and Non-White Professionals

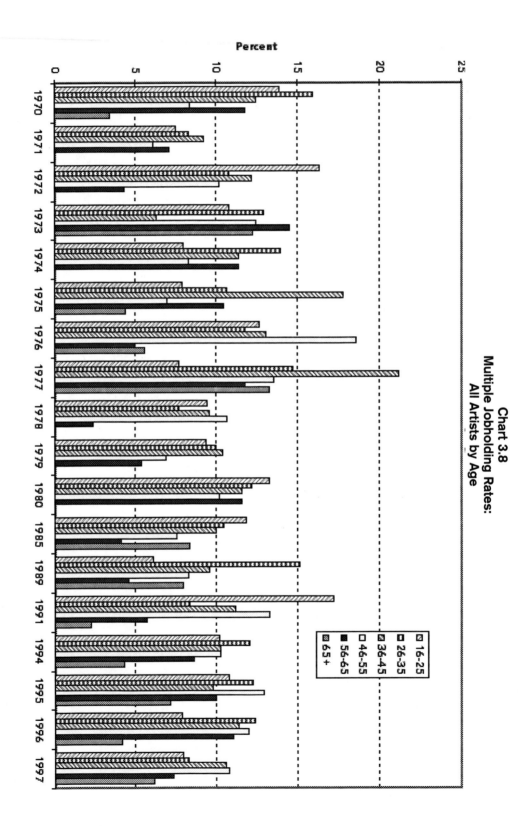

Chart 3.8
Multiple Jobholding Rates:
All Artists by Age

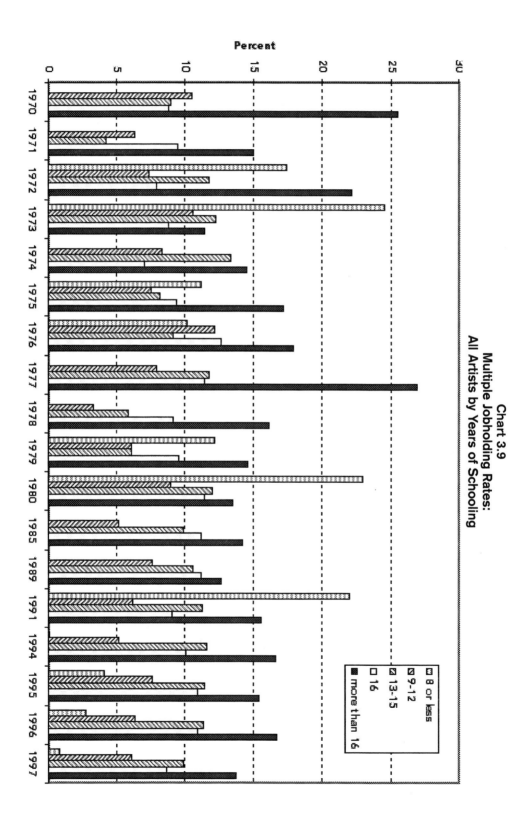

Chart 3.9
Multiple Jobholding Rates:
All Artists by Years of Schooling

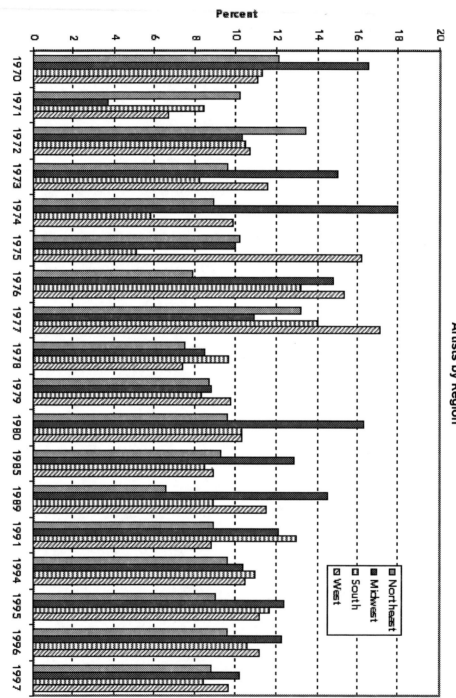

Chart 3.10
Multiple Jobholding Rates:
Artists by Region

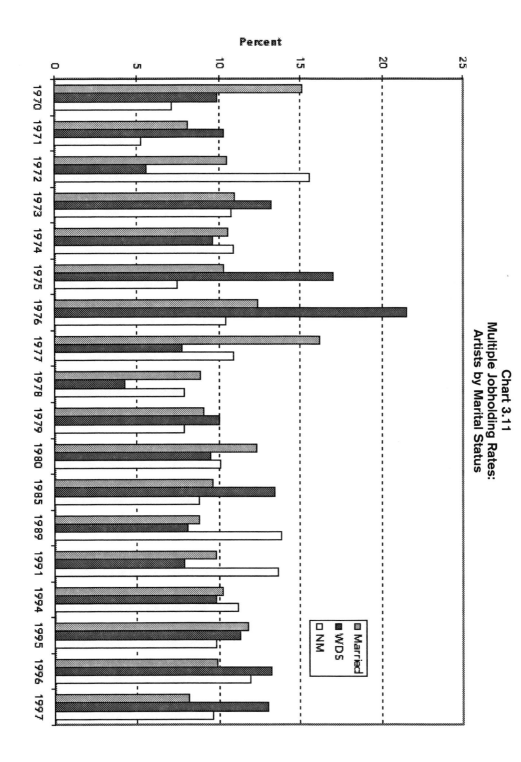

Chart 3.11
Multiple Jobholding Rates:
Artists by Marital Status

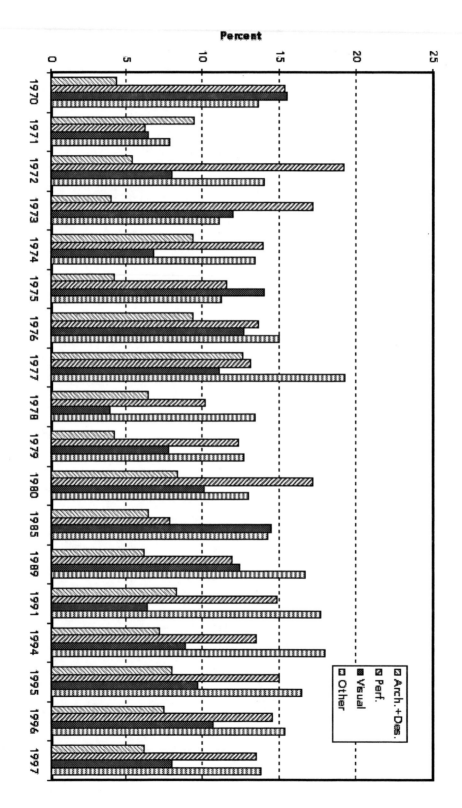

Chart 3.12
Artists' Multiple Jobholding Rates:
1970–1997

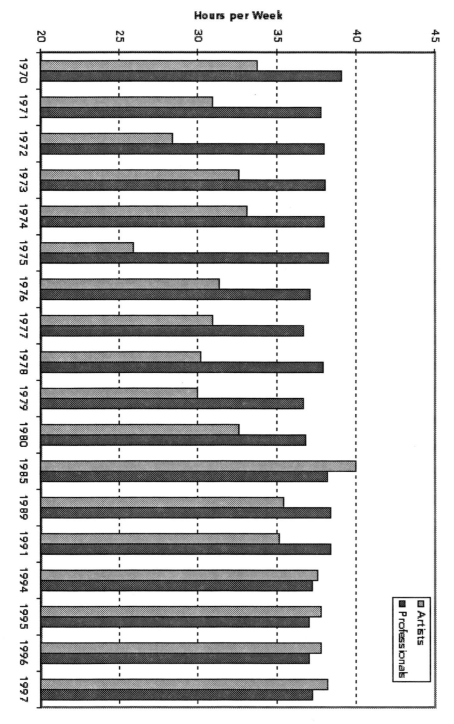

Chart 3.13
Hours Worked on First Job
Artists and Professionals

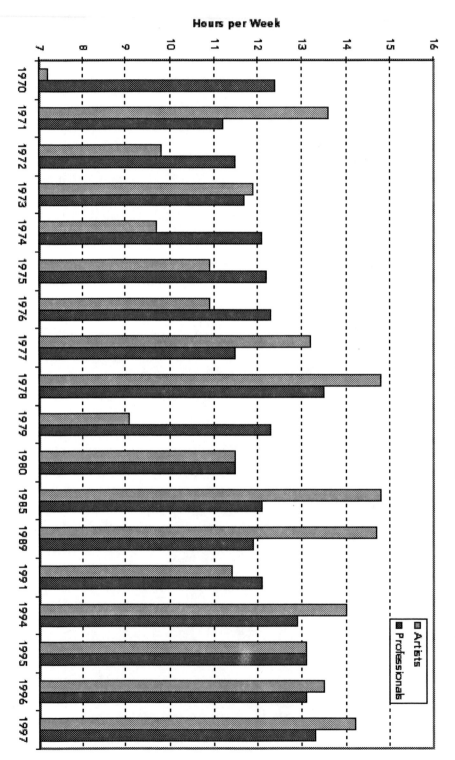

Chart 3.14
Hours Worked on Second Job
Artists and Professionals

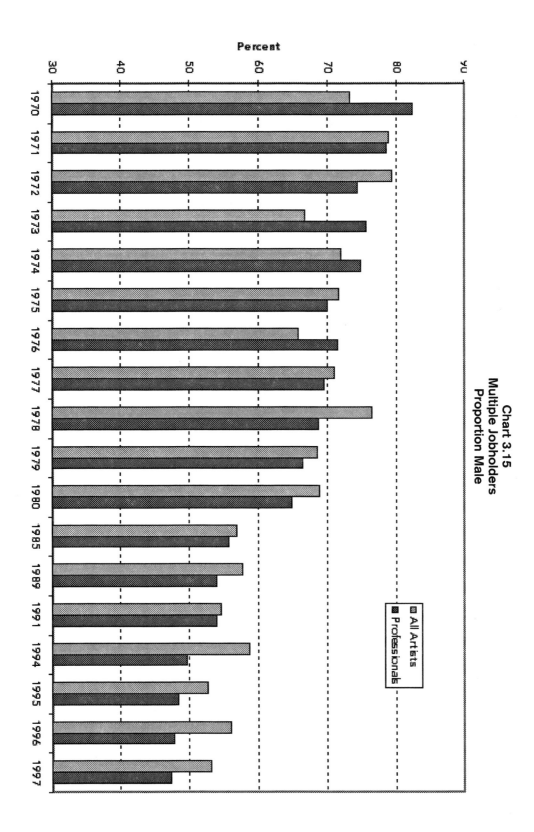

Chart 3.15
Multiple Jobholders
Proportion Male

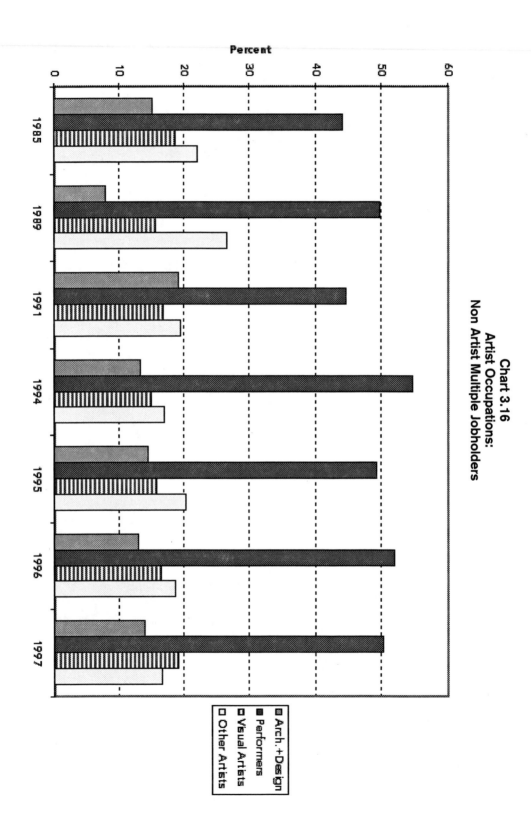

Chart 3.16
Artist Occupations:
Non Artist Multiple Jobholders

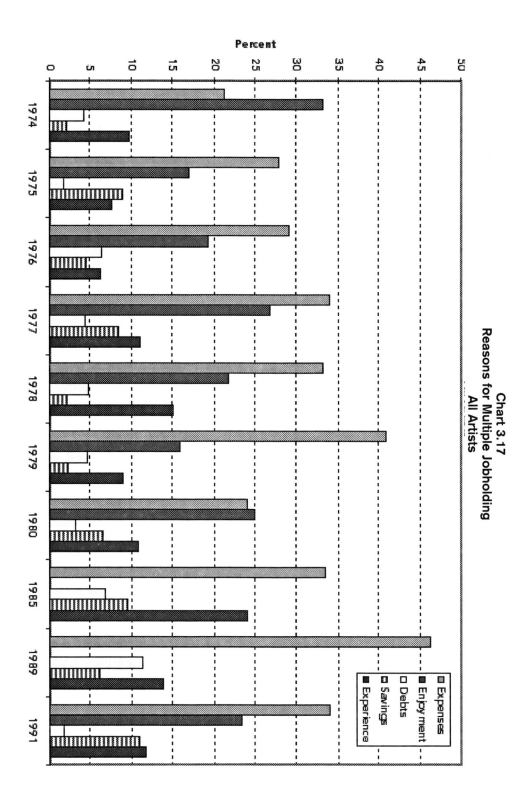

Chart 3.17
Reasons for Multiple Jobholding
All Artists

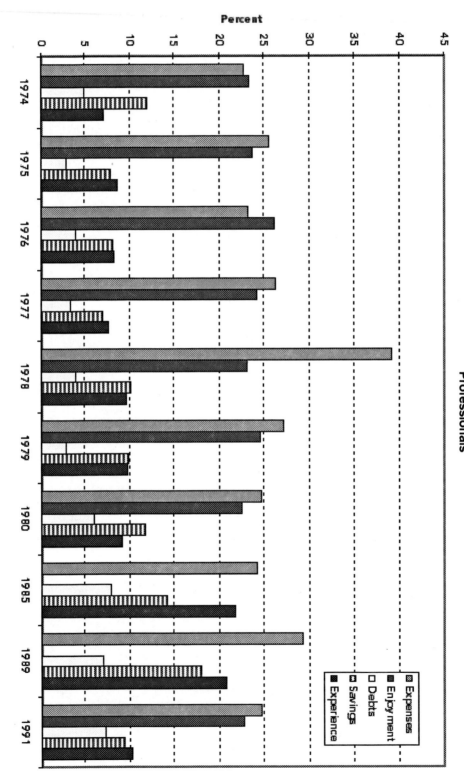

Chart 3.18
Reasons for Multiple Jobholding
Professionals

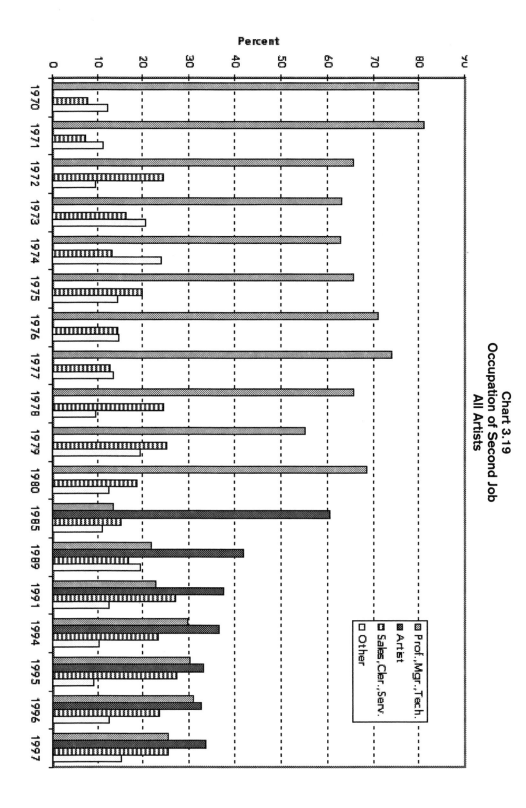

Chart 3.19
Occupation of Second Job
All Artists

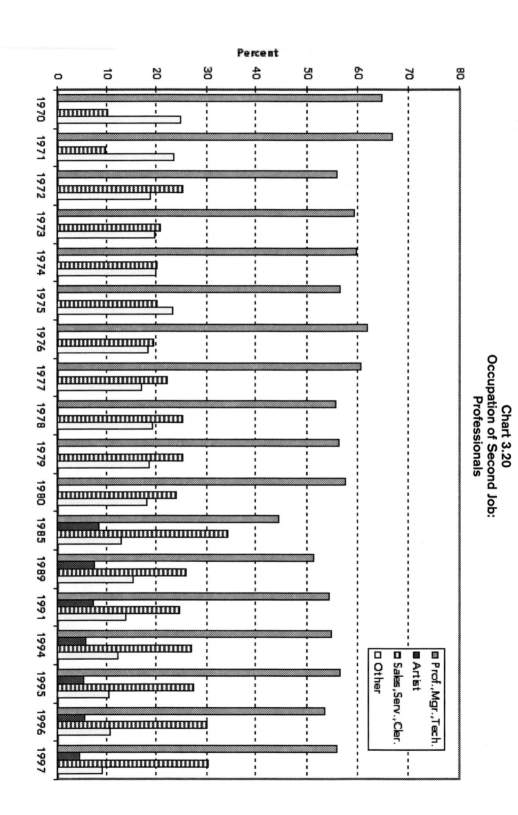

Chart 3.20
Occupation of Second Job:
Professionals

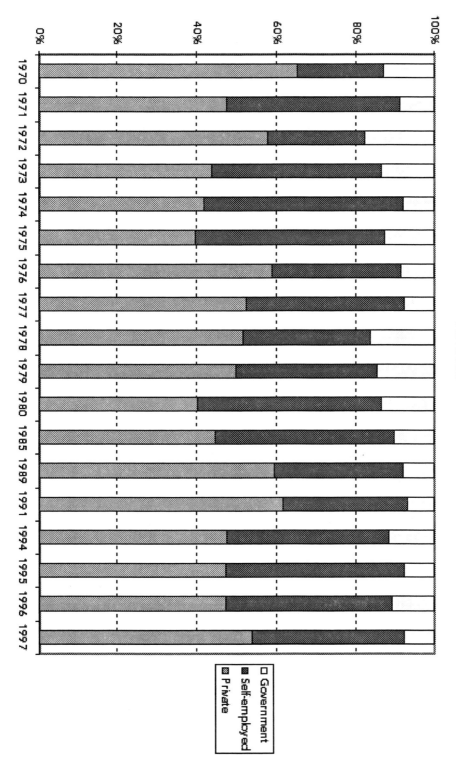

Chart 3.21
Sector of Second Job:
All Artists

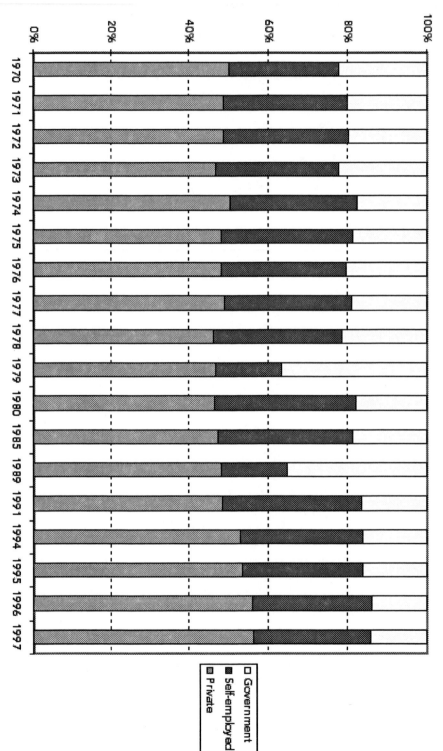

Chart 3.22
Sector of Second Job:
Professionals

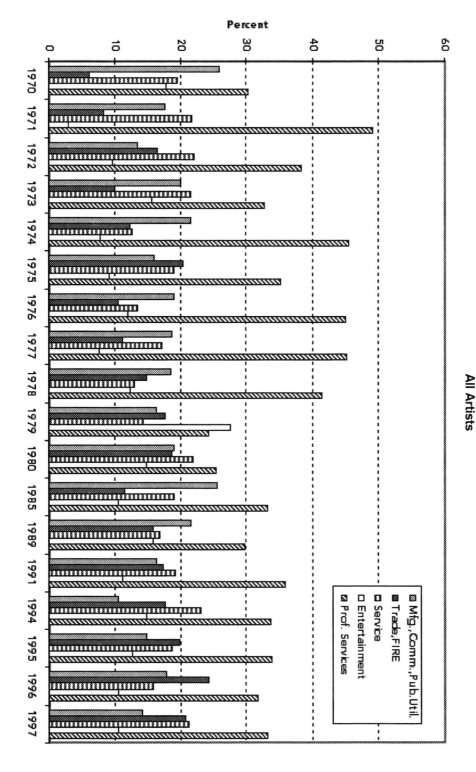

**Chart 3.23
Industry of Second Job:
All Artists**

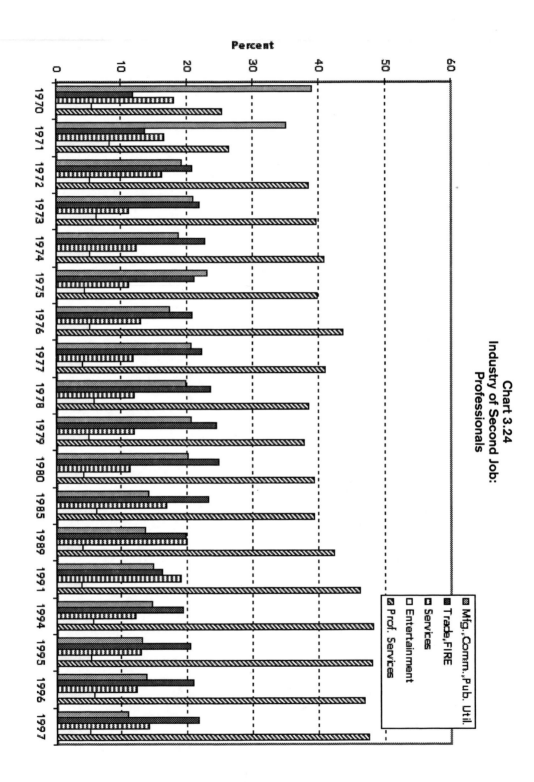

Chart 3.24
Industry of Second Job:
Professionals

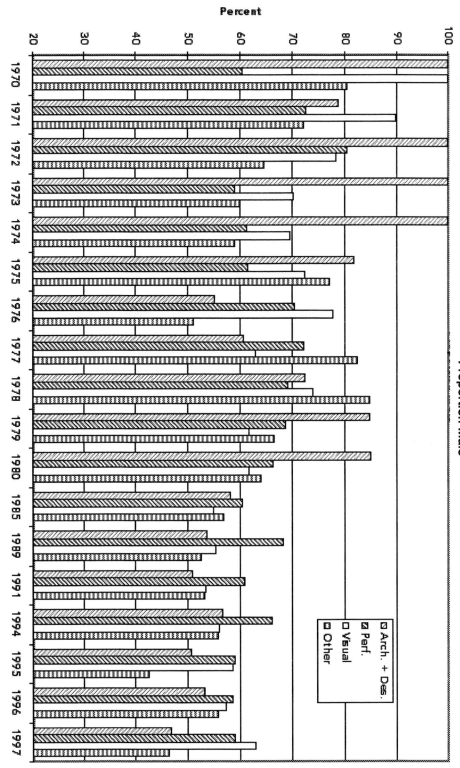

Chart 3.25
Artist Multiple Jobholdings
Proportion Male

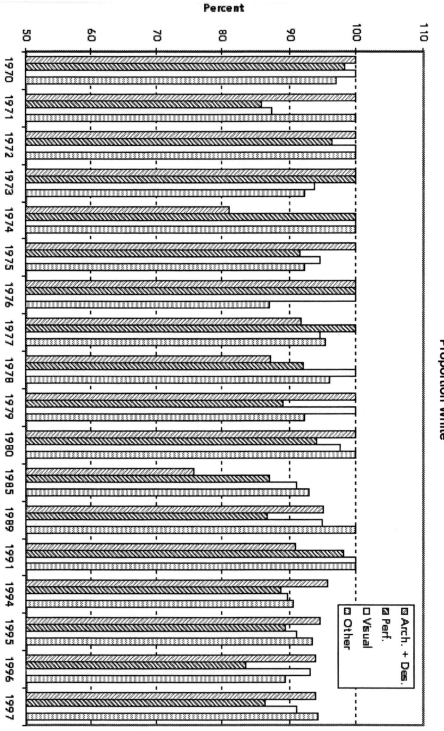

Chart 3.26
Artist Multiple Jobholdings
Proportion White

Chart 3.27
Artist Multiple Jobholdings
Years of Schooling

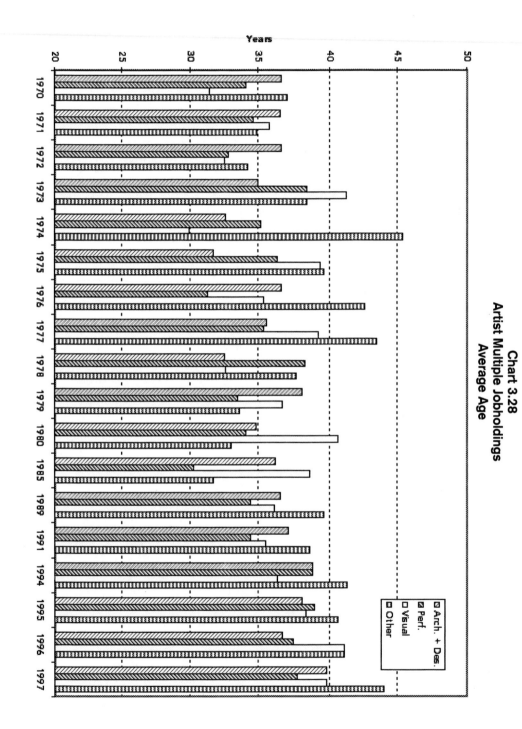

Chart 3.28
Artist Multiple Jobholdings
Average Age

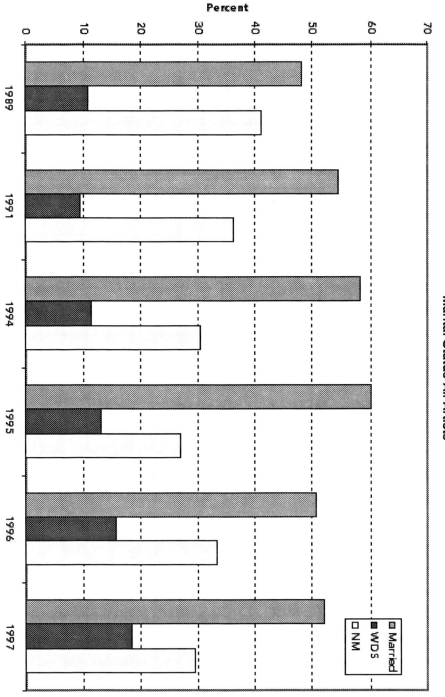

Chart 3.29
Artist Multiple Jobholdings
Marital Status-All Artists

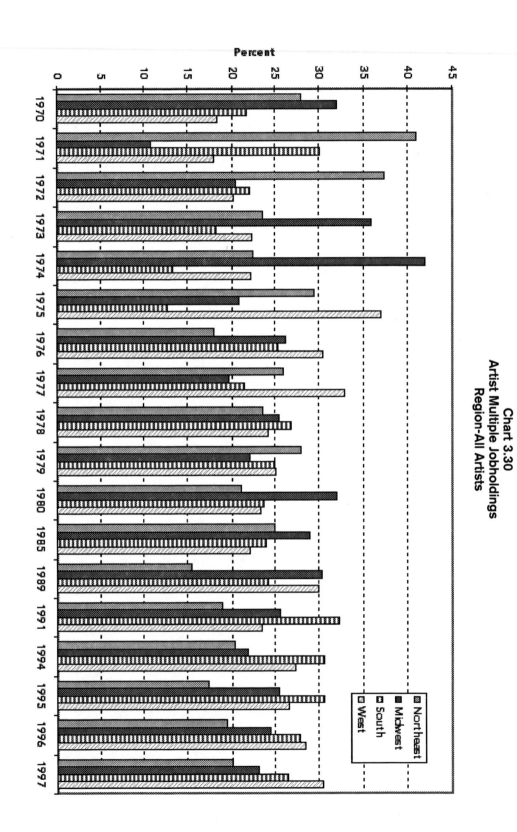

Chart 3.30
Artist Multiple Jobholdings
Region-All Artists

CHAPTER 4 MOONLIGHTING BY ARTISTS IN OTHER COUNTRIES

The practice of multiple jobholding by American artists has been clearly established through the CPS and special surveys of artists. As has been shown, it is a behavior that has existed, more or less to the same degree, for the past twenty-seven years through periods of economic growth and decline, and changes in public policy toward the arts. What's not clear is whether the experiences of American artists are unique to the social, cultural, political and economic environment in this country, or if they are replicated in other countries throughout the world.

Government support for the arts in the United States is quite limited relative to support in other countries throughout the world. On a per capita basis the United States tends to be found at the bottom of most rankings, especially for direct expenditures on the arts. In a study of 1987 government expenditures, Throsby estimates that in the United States all levels of government combined spent about $3.30 per person in direct support of the arts. This was about twenty percent of the amount spent in the next closest country in the study, the United Kingdom (Throsby, 1994, Tables 1, 21). In countries like the Netherlands, where social support for the arts is very important to the population, per capita expenditures were ten times larger. Schuster, in a study for the National Endowment for the Arts, finds that the United States ranks above only the United Kingdom when indirect expenditures (e.g., tax subsidies) are included (Schuster, 1985). While this more optimistic view may be preferable, indirect subsidies for the arts are likely to have little direct impact on artists since they tend to benefit non-profit arts institutions rather than artists.

There are several reasons to believe that government support for individual artists in the United States has only gotten worse in recent years. Primary among them is that spending by the National Endowment for the Arts (NEA) has declined by more than forty percent in nominal dollars from 1985 to 1997 (NEA, 1998). Clearly, the decline in real dollars is even larger. At the same time the United States population, and the number of people working as artists, has grown considerably. Also, the history of grants to individual artists, which the NEA initiated in 1967 with 187 grants to individuals in fiscal year 1968 (NEA, no date, 21), has worsened considerably. Currently only three programs are left: a traditional grant program for individual artists in literature, and two honorific programs for folk and traditional arts and jazz artists. In its 1997 fiscal year the

NEA granted only 53 awards directly to artists in these programs at a cost of $960,000, or about one-percent of its budget for the year.

In countries throughout the world where grants to individual artists are more extensive and more generous, grants to artists have a greater potential to influence their labor market behavior. Finland, for example, provides grants to its artists—ndividually and "working groups" of artists—that are designed to provide tax free income equivalent to the after tax income of the average member of the workforce (Heikkinen, 1998, 113). These grants are available to artists for up to five years. In 1996 almost 20 percent of Finnish artists received grants from the government (Heikkinen, 1998, Table 1, 114). The Finnish policy makers see the "primary function of grants is usually supposed to be the same as in non-arts work, that is to buy time for arts work." (Heikkinen, 1999, 19.) The basis for the support is "the idea of ensuring the prerequisites of artistic work for artists in a situation of limited markets and very few sources for private support. The idea is to free artists from the constraints of the markets." (Heikkinen, 1999, 18)

In Canada, artists in most disciplines can also apply for individual grants which differ in value depending on whether the artist is an "established" artist, a "mid career" artist, or an "emerging" artist. The more established the artist the larger is the potential grant. The established visual artist is able to obtain a grant of $34,000 (Canadian) while the maximum grant available for emerging artists is $5,000. In its 1997 fiscal year, the federal arts agency in Canada awarded 1,102 grants directly to artists expending $12,522,253 that was approximately 14 percent of the agency's total revenues for the year (Canada Council).

This chapter will examine the multiple jobholding behavior of artists in five countries. Two of them, the Netherlands and Finland, have histories of considerable government support for the arts and their artists, and the other three, Australia, Canada, and the United Kingdom, provide more support than in the United States but not at the level of the former. Similar to the United States, the information on multiple jobholding among artists in these countries is primarily obtained from special surveys of artists and therefore is subject to the same strengths and weaknesses of this method of data collection. The most troublesome ones for comparative purposes are the limited numbers of artistic occupations usually covered by any single survey, and the possible lack of a representative sample of artists included in the survey.

Multiple jobholding among artists in Canada is confirmed by two surveys undertaken in the late 1970s. One was a survey of visual artists (Bradley, no date); the other was a survey of freelance writers (Harrison, 1982). In both surveys the vast majority of these Canadian artists worked at some other income

generating activity besides producing their art. Only 20 percent of the visual artists surveyed were self-employed full-time artists without any other labor force attachment (Bradley, nd., 26). Fully 30 percent reported that they were full-time artists with additional part-time attachments to the labor force, while another 7 percent indicated that they were full-time in both their arts activities and supplemental labor force activities. The largest group of visual artists, 44 percent, identified themselves as part-time artists with varying degrees of attachment to the non-arts labor force. The visual artists who were not multiple jobholders were found to be older than those who were multiple jobholders (Bradley, 34).

Multiple jobholding among freelance writers in Canada was somewhat less common with 63 percent holding an additional full-time or part-time job along with their writer job (Harrison, 1982, 79). Four out of ten Canadian freelance writers worked at full-time jobs along with writing, and almost 30 percent of the full-time writers worked at part-time jobs to supplement their incomes as well. The likelihood of multiple jobholding differed by writing genre. Poets were the most likely (almost 90 percent) and non-fiction writers the least likely (about 55 percent) to have second jobs.

The findings of a more comprehensive and more recent survey of artists in Australia undertaken in 1988 (Throsby and Thompson, 1995) identify very similar patterns. Almost three-quarters of all the artists surveyed held some other job along with their artistic work (Throsby and Thompson, Table 2, 5). As in the United States and Canada, the proportion of artists who were multiple jobholders varied by artistic discipline. Almost 90 percent of the dancers held some other job, making them the most likely to do so, while approximately 60 percent of the craft artists were multiple jobholders. Of those who worked outside their art, 12 percent held both arts-related jobs (e.g., teaching in their art form and arts administration) and non-arts jobs sometime during the year. Dancers who worked outside their art form were the most likely to have held both types of jobs (almost 40 percent), while crafts artists were the least likely. Australian actors who worked outside of acting were the most likely to have held second jobs that were not related to their art (42 percent). Composers were the least likely to do so (11 percent) and the most likely to also have worked in a job related to their primary artistic occupation (PAO).

An even more recent survey in Australia, undertaken in 1993, suggests a continuation of the same patterns of multiple jobholding. Visual artists were found to be slightly more likely than craft artists to work at some other job outside their art (80 percent versus 75 percent). In either case, more than three-quarters of these Australian artists held some other job during the year (Bardez and

Throsby, 1997). Of those who worked outside their art, about 60 percent of both the visual and craft artists worked solely at arts-related jobs. The other multiple jobholders were almost equally split between those who only held non-arts jobs and those who held both arts-related and non-arts jobs (Bardez and Throsby, 1997, Table 13, 17). Even though comparable information on other Australian artists is not reported, information on the amount of time worked provides additional evidence of multiple jobholding by Australia's other artists in 1993 (Throsby and Thompson, 1994). Taken together, all Australian artists were found to have worked for an average of 47 hours per week (Throsby and Thompson, 1994, Table 14, 22). This is clearly more than full-time according to accepted definitions of full-time work schedules. They spent an average of nine of those hours associated with non-arts work. Writers had the longest workweek (50 hours) and spent the most time in non-arts work (15 hours), while dancers had the shortest workweek at 37 hours but spent 10 of those hours in non-arts work. (The dancer's workweek may not reflect unpaid practice time.) Additionally, both surveys found that many artists were multiple jobholders within the arts as well. The artists spent, on average, three hours per week in "creative work" in second arts fields in 1993.

The evidence on artists' multiple jobholding in the United Kingdom is supportive of the findings already described for other countries. The reports either deal with the amount of time spent at various income generating activities, as in some of the Australian reports, or the sources of artists' incomes. All the surveys of artists in the UK are from the late 1980s or early 1990s (Towse, 1996, Appendix 1) and are for different parts of the country. A survey of Welsh artists found that they spent, on average, two-thirds of their time working in their primary arts occupation, but they also spent the remaining one-third in arts-related and non arts work (Towse, 1996, 13). Similarly, Scottish artists averaged twelve hours per week teaching in addition to the 46 hours per week they spent working as artists and in arts-related work (Towse, 1996, 13). A 1994/1995 survey of visual artists from throughout the United Kingdom found that only 11 percent earned all their income from working as artists and 60 percent of them earned less than half their income from working as artists (O'Brien, 1998, Table 8, 41). Additionally, fully one-fifth of visual artists indicated that teaching was their most important source of income, and an additional 16 percent identified work that was not related to their art as the most important source of their income (O'Brien, 1998, Table 9, 41).

The Netherlands, unlike most countries, has had a long history of support for artists, especially its visual artists. After World War II a national policy,

known as BKR, was implemented to provide visual artists with a secure income and to isolate them from the "crudeness of the market" (Rengers, 1998, 56). One result of this policy was a significant increase in the number of artists in the 1970s. Since then the policy has been modified so that today a major criterion for support is the quality of the art. Even with the extensive support from the government, a survey of visual artists in the Netherlands found that while all had earnings in 1995 from working as artists, more than one-third earned income from teaching and more than one-quarter had earnings from work unrelated to the arts (Rengers, 1998, Table 2, 61). This would certainly suggest that the Dutch artists, too, are multiple jobholders. Additional information for 1996 and 1997, from the same survey, reaffirmed the finding that almost one-quarter of Dutch artists had non arts earnings along with their arts earnings (Poot and van Puffelen, 1999, 40).

As already discussed, Finland is another country that provides a considerable portion of its artists with direct government support. Yet, recent surveys of fine artists, crafts and design artists, and actors and dancers in Finland undertaken over the period 1993–1996 found a considerable amount of multiple jobholding among them (Karhunen, 1998). Among the Finnish fine artists only 21 percent worked only in their primary arts occupations (Karhunen, 1998, Table 2, 151), and fully 60 percent indicated "multiple employment status" at the time of the interview. Additionally, one-third of the fine artists indicated that they worked as an artist and in an arts-related job that, as in most other countries, primarily was teaching art. Approximately 40 percent of these artists had also worked in both arts-related jobs and non-arts jobs during the survey period (Karhunen, 1998, 154). A considerably smaller proportion of actors and dancers, only 16 percent, identified themselves as having a "multiple employment status." This may reflect the willingness of governments at all levels in Finland to support theater, even though these subsidies have diminished in recent years. The craft and design artists fit somewhere between the fine artists and the actors and dancers in terms of multiple jobholding. Approximately 30 percent indicated that they had "multiple employment status" at the time of the survey, and almost one-quarter had worked in non-artistic occupations, primarily for economic reasons, sometime during the year (Karhunen, 1998, 154). A survey of Finnish musicians who had graduated from music school found that 12 percent earned income from working in either arts-related or non-arts jobs (Karhunen, 1998).

From this brief review of research and available information it appears that one of the "constants" of artists' careers, regardless of the country and its policies

toward support of its artists, is that many artists work at more than one income generating activity during the year. It is also true that these multiple jobs are often held at the same time. Unlike multiple jobholding for most workers, the second or third income generating activity is more often than not completely unrelated to the artist's primary occupation. This seems to be true in countries that provide relatively little direct government support for its artists, such as the United States, and in those that provide quite a considerable amount of support directly to its artists.

CHAPTER 5 CONCLUSIONS AND POLICY IMPLICATIONS

Drawing upon annual information in the Current Population Survey for a period of almost 30 years, this study documents what several direct surveys of American artists had already uncovered—that American artists are more likely to hold multiple jobs than the average worker. The CPS data consistently show that artists moonlight more frequently than workers in most other occupations, including other professional workers, the group to whom they are compared in this study.

The practice of moonlighting should be viewed in the broader context of how artists fare in the job market. Artists' job markets differ from those of many other professional occupations in a variety of ways. Most of these differences lead to less attractive outcomes for artists.

Unlike those of many other professions, artists' job markets are relatively open. It is more common for members of other professions to erect entry barriers, such as minimum levels of education and training or licensing and certification requirements, and then to create professional associations or licensing boards to certify that these entry qualifications are met. Although this process may ensure that a certain standard of quality and competency is met in the occupation, it also ensures more limited entry, more stable employment, and higher salaries for workers who qualify.

The labor market for artists is not structured this way. For most artist occupations, minimum levels of education and certification requirements do not exist. (These kinds of requirements do exist in the architect profession, which more closely resembles several other non-artistic professions. They also exist for college teachers of art, drama and music.) Although each artist profession is associated with an average amount of formal education, individuals can declare themselves to be artists with little or no formal training or work experience in their art.

Other distinct characteristics of labor markets for artists are the lack of stable jobs and the lesser availability of full-time jobs. For example, performing artists often do not work for the same employer for very long. Even those who are capable of finding full-time work in their profession often need to move from one gig to another, or from one acting job to another, in order to maintain it. Performing artists who do have a stable source of employment nevertheless may not have an opportunity to work full-time, year-round. Examples of this

are classical musicians and dancers working for small or regional orchestras and companies. Job market conditions such as those cited above apply equally to persons such as showgirls, rock musicians, and radio disk jockeys, whom we often fail to realize are also members of these same occupations.

The job market for creative artists, such as authors and visual artists, is different but yields many of the same outcomes. Here the typical member is more likely to be self-employed, and thus less likely to be unemployed. Like performing artists, however, creative artists may find that there is insufficient demand for their work to earn a full-time living from their chosen occupation, and may report working only part-time in their first job as well as holding a second job.

Job markets for college and university teachers of art, drama and music are also different. In general, college teaching cannot be construed as a full-time year-round occupation. Members of this profession, while having relatively stable jobs, often do not work summers, and do extra work during the academic year, whether it is research, consulting, writing, or art. Again, there exists a desire or need for second or third jobs.

Another perspective on the dynamics of many artist labor markets can be found in the theory of winner-take-all markets. In the economics literature, this concept was initially formalized by Rosen (1981), and popularized by Frank and Cook (1995). As described by Frank and Cook, this theory describes winner-take-all markets as characterized by "reward by relative performance" and asserts that "(r)ewards tend to be concentrated in the hands of a few top performers, with small differences in talent or effort often giving rise to enormous differences in incomes" (p. 24). They also discuss the relationship of this concept to job markets for artists:

> In many other winner-take-all markets, by contrast, losing contestants receive some modest payment. People in the arts, for instance, often support themselves by moonlighting as waiters or taxi drivers.... Such payments [to non-winners], however, do nothing to alter the underlying tendency of winner-take-all markets to attract too many contestants. Given the familiarity of the "starving artist" syndrome, it is easy to see that the losers in many winner-take-all markets—failed actors, painters, writers, and musicians, to name a few—do worse than they would have done in other careers (p. 110).

In other words, although a few talented (or lucky) artists earn large incomes for their work, median artistic earnings are relatively low. This theory capitalizes on the openness of artist job markets and blends this trait with the inherent attractiveness of these occupations as offering a small chance to become

wealthy and famous. It predicts an outcome of constant oversupply, with many workers becoming marginalized, by low salary or sporadic employment or both.[1] One could argue that this oversupply is exacerbated by the fact that some artists see their profession as a calling, and are less likely to give up and pursue a different occupation if they are unsuccessful than an underemployed accountant or restaurant manager.

How these unique aspects of artist occupations interact to affect labor market outcomes in 1997 is summarized in Table 5.1. In this table several labor market indicators are presented for artists, other professionals, and all workers. This table is the only one in this monograph that breaks down artist data to the individual three-digit occupation level. This breakdown, though yielding less statistically reliable results for individual artist occupations, is less problematic for 1997, a year in which we can draw from, and combine, twelve monthly reports on moonlighting and other labor market behavior.

Some of the information in this table has been discussed in earlier chapters, such as the higher rates of moonlighting among artists, and the smaller number of hours worked in primary jobs. In addition, it has already been noted that artists' earnings are lower than the average in other professional occupations. Other information not presented earlier reflects other longstanding trends in these occupations. For example, the artist unemployment rate has averaged about twice that of other professional workers for decades, and has remained roughly equal to the unemployment rate in the labor force as a whole. Rates of part-time jobholding by artists have traditionally been greater than among other professions and among all workers.

In addition, this table enables one to see more clearly how these labor market characteristics differentially reflect different work conditions in individual artist occupations. The necessity to change jobs frequently in the performing arts leads to time gaps between jobs, and hence to the highest unemployment rates. Some of the highest moonlighting rates are found here; obviously second jobs are often used to fill some of these gaps, as well as to supplement insufficient work as a performer in any given week. Creative artists, such as authors, painters and sculptors, designers, and photographers, are often self-employed and have a greater ability to control work times in their profession. Nevertheless, they have part-time employment rates well above the average of other professionals. College and university art, drama, and music teachers have

1. Note that some winner-take-all labor markets, such as those for lawyers and plastic surgeons, do not lead to adverse financial outcomes for the "losers." In these cases, however, entry barriers limit the number of participants.

stable jobs and low unemployment, but these jobs frequently are not full-time, and second jobs are often taken to increase earnings. These second jobs, however, often are complementary to the primary job.

These numbers also show the "uniqueness" of architects among artist professions—their job characteristics more closely resemble those of some non-artistic professions, with low rates of unemployment, part-time employment and moonlighting, and a longer workweek. Though not reported here, architects' earnings also more closely resemble the earnings of other well-educated professionals.

Should artists' adverse job market outcomes be a matter of public concern? And if so, what should be done? These questions are raised at a time of minimal direct government support for artists in the United States. Even if the likelihood of public support were greater, several aspects of artistic careers make developing strategies to reduce artist moonlighting and unemployment a difficult task.

One reason why it is politically difficult to design and implement programs of labor market assistance for artists is that their education levels and earnings are higher than those of the average worker. Although artists face unusual job market stress, their employment difficulties are not of the same order of magnitude as those of workers with little education or job skills, such as minority teenagers or welfare mothers. In an era of scarce governmental resources, programs of job assistance to artists will have to stand in line behind programs of support to more needy groups.

A second reason lies in the discussion of motives for moonlighting. Not all motives for taking a second job imply job market duress. Although the most often-cited reasons for taking second jobs involve limited or constrained primary job opportunities, other reasons were often cited. Among these were "I enjoy the work," "I want to obtain a different experience," and "it complements my work." It is hard to justify public support to reduce moonlighting rates among artists when these are among the reasons they give for the activity.

This is not to argue against government programs of financial support for artists. There are valid reasons in favor of government support of artists; among them are providing support for valuable work whose benefits may not be fully reaped by the artist, and preserving our cultural heritage and diversity. However, it should also be realized from the outset that programs of public support for artists are unlikely to significantly affect the job market outcomes detailed above, for three reasons:

(1) The number of artists in the labor market continues to grow rapidly. There are now roughly two million artists in the labor force. As noted, barriers

to entry do not exist in most artist labor markets. When the economy gets better, more people choose to pursue artistic careers. Subsidies to artists will make recipients better off, but they will also stimulate additional entry into artist labor markets. As a result, levels of unemployment, part-time and multiple jobholding will thus change less in response to these subsidies.

(2) The numbers in Table 5.1 reflect the average of outcomes over practitioners of "high" and "fine" art and practitioners of "other" art. To reduce unemployment, dependence on part-time work and moonlighting among artists (as defined by the broad occupational groups reported on by the NEA), it would be necessary to provide support to artists across the board. This in turn would require supporting a greater variety of artists than those traditionally viewed as in the domain of government support.

(3) Finally, even when using of a more narrow definition of "artist" for policy purposes, the fact remains that artists living in countries with far greater direct government support moonlight at roughly the same rate as American artists.

The evidence indicates that public support for artists, while justifiable for other reasons, is not likely to reduce moonlighting rates, and is unlikely to reduce unemployment and part-time jobholding rates as well. An encouraging sign is that, in the tight labor market of the past several years, the differences in these rates that have traditionally existed between artists' and other professionals have somewhat narrowed.

Because the labor market stresses facing artists continue to be a topic of interest, this monograph concludes with a plea for better information in this area. The decennial Census has never reported information about moonlighting. The Current Population Survey reports on moonlighting behavior and on related information, such as occupation and industry of the second job, but only in a given week, and it does not provide a breakdown of earnings derived from multiple jobs. It is hoped that Census personnel will become more responsive to these gaps in their information collection. Otherwise, it may be necessary to increase support for special surveys of artists, and especially for longitudinal surveys, in order to answer the many remaining questions about artists as workers.

Table 5.1
The Employment Status of Artists in 1997

	Number (000)	Unemployment Rate	Part-time Employment Rate	Multiple Job Holding Rate	Hours Worked per Week: Job 1	Hours Worked per Week: Job 2
All Workers	136,514	4.6	18.1	6.6	39.4	14.4
All Other Professionals	22,012	1.9	15.0	8.9	40.1	13.3
All Artists	1,970	4.5	24.5	9.2	38.2	14.2
Actors/directors	151	10.4	15.3	9.0	43.6	14.5
Announcers	62	4.4	35.1	18.2	32.1	16.1
Architects	171	1.4	5.8	3.9	44.5	13.3
Authors	140	2.9	29.2	12.3	37.0	14.7
Dancers	34	14.1	52.9	8.1	29.9	10.1
Designers	685	3.7	20.7	6.7	39.1	12.5
Musicians/composers	164	6.8	49.2	17.0	25.6	14.4
Painters/sculptors	26.1	3.0	22.8	7.8	39.2	14.1
Photographers	137	4.6	26.9	8.4	37.8	13.4
Teachers (college) of art	36	0.6	29.3	29.5	33.6	15.8
Other artists	127	5.9	30.6	10.8	36.5	17.6

Notes: Statistics on number of workers and unemployment rates are based on the civilian labor force; statistics on part-time employment rates, multiple job-holding rates, and hours worked are based on the employed civilian labor force. All data are based on authors=calculations from the 1997 CPS.

BIBLIOGRAPHY

Abdukadir, G. (1992) Liquidity Constraints as a Cause of Moonlighting. *Applied Economics*, 24, 1307–1310.

Alper, N. and Galligan, A. (1999) Recession to Renaissance: A Comparison of Rhode Island Artists, 1981 and 1997. *Journal of Arts Management, Law and Society.*

_____ and Morlock, M. (1982) Moonlighting Husbands or Working Wives: An Economic Analysis. *Journal of Family Issues*, Vol. 3, No. 2, June, 181–198.

_____ and Wassall, G. (1996) The Write Stuff: Employment and Earnings of Authors 1970–1990, in *Artists in the Work Force: Employment and Earnings, 1970–1990*, NEA, Research Report #37, 13–58.

_____, *et al* (1996) *Artists in the Work Force: Employment and Earnings, 1970–1990*, National Endowment for the Arts, Research Division Report #37.

Altonji, J. G., and Paxson, C. H. (1988) Labor Supply Preferences, Hours Constraints and Hours-Wage Tradeoffs. *Journal of Labor Economics* 6, 254–76.

Amirault, T. (1997) Characteristics of Multiple Jobholders, 1995. *Monthly Labor Review*, March, 9–15.

Bardez, C. and Throsby, D. (1997) *Similarity and Difference: Craftspeople and Visual Artists in Australia*. Redfern, Australia: Australia Council for the Arts.

Bradley, I. (nd) *Profiles of Visual Artists in Canada, 1978*. Ottawa: Research and Statistics Directorate, Arts and Culture Sector, Department of Communications.

Bureau of Labor Statistics. (various years) Multiple Jobholders in May. Washington, DC: U.S. Department of Labor, Bureau of Labor Statistics.

Canada Council for the Arts. (No date) Fortieth Annual Report and Supplement: 1996–1997 [Online]. Available: www.canadacouncil.ca/ar40/report.htm [August 18, 1999].

Conway, K. S., and Kimmel, J. (1992) Male Labor Supply Estimates and the Decision to Moonlight. Upjohn Institute Working Paper 92–09.

_____. (1995) Who Moonlights and Why? Evidence from the SIPP. Upjohn Institute Working Paper 95–40.

Frank, R. H., and Cook, P. J. (1995) *The Winner-Take All Society*. New York: The Free Press.

Harrison, B. (1982) *Canadian Freelance Writers: Characteristics and Issues*. Ottawa: Research and Statistics Directorate, Arts and Culture Sector, Department of Communications.

Heikkinen, M. (1998) A Borderline Case: Finnish Artist Policy and the Field of Applied Graphics, in *Economic of Artists and Arts Policy: Selection of Papers*, ed. M. Heikkinen and T. Koskinen, Helsinki: The Arts Council of Finland, 111–128.

_____. (1999) Economic and Non-Economic Uses of Public Support for Artists. In proceedings of Artists' Career Development and Artists' Labour Markets, Support and Policies for Artists: An International Symposium on Cultural Economics in Tokyo, 28–30 May 1999, Tokyo: ACEI and Japan Association for Cultural Economics.

Highfill, J. K., Felder, J. and Sattler, E. L. (1995) Multiple Worker Households and Multiple Job Holding: Rigid Vs. Flexible Hours. *The American Economist* 39, 40–47.

Jeffri, J., ed. (1989) *Information on Artists: Cape Cod*. New York: Columbia University, Research Center for Arts and Culture.

Karhunen, P. (1998) The Labour Market Situation of Graduated Artists. In *Economic of Artists and Arts Policy: Selection of Papers*, ed. M. Heikkinen and T. Koskinen, Helsinki: The Arts Council of Finland.

_____. (1998) A Portrait of a Woman as an Artist-Some Research Results Concerning the Career Paths of Female Artists. Paper presented at the 10th International Conference on Cultural Economics, Barcelona, June 14–17.

Katz, J. (1996) Occupational Divide, *Regional Review*, Federal Reserve Bank of Boston, Spring.

Kay, A., and Butcher, S. (1996) Employment and Earnings of Performing Artists, 1970–1990. In Alper, et al., *Artists in the Work Force: Employment and Earnings, 1970–1990*.

Kingston, P. and Cole. J. (1986) *The Wages of Writing: Per Word, Per Piece, or Perhaps*. New York: Columbia University Press.

Krishnan, P. (1990) The Economics of Moonlighting: A Double Self-Selection Model. *The Review of Economics and Statistics* 72, 361–367.

National Endowment for the Arts. (1998) 1997 Annual Report [Online]. Available: www.arts.endow.gov/learn/97Annual/First.html [1999, August 16].

_____. (nd) *National Endowment for the Arts 1965–1995: A Brief Chronology of Federal Involvement in the Arts.* Washington, DC: National Endowment for the Arts.

Netzer, D., and Parker, E. (1993) *Dancemakers*, National Endowment for the Arts, Research Division Report #28.

O'Brien, J. (1998) Professional Status as a Means of Improving Visual Artists' Incomes. In *Economic of Artists and Arts Policy: Selection of Papers*, ed. M. Heikkinen and T. Koskinen, Helsinki: The Arts Council of Finland.

Paxson, C. H., and Sicherman, N. (1996) The Dynamics of Dual Job Holding and Job Mobility. *Journal of Labor Economics* 14, 357–393.

Perlman, R. (1966) Observations on Overtime and Moonlighting. *Southern Economic Journal*, 33, 237–244.

Poot, T. and van Puffelen, F. (1999) Measuring the Income of Visual Artists in the Netherlands with the Aid of Panel Surveys. In proceedings of Artists' Career Development and Artists' Labour Markets, Support and Policies for Artists: An International Symposium on Cultural Economics in Tokyo, 28–30 May 1999.

Rengers, M. (1998) Visual Artists in the Netherlands: Civil Servants, Self-employed or Both? In *Economic of Artists and Arts Policy: Selection of Papers*, ed. M. Heikkinen and T. Koskinen, Helsinki: The Arts Council of Finland.

Rosen, S. (1981) The Economics of Superstars. *American Economic Review* 71, 845–58.

Ruttenberg, Friedman, Kilgallon & Associates. (1981) Working and Not Working in the Performing Arts: A Survey of Employment, Underemployment and Unemployment Among Performing Artists in 1980. Washington, DC: Labor Institute for Human Resources Development.

Schuster, J. (1985) *Supporting the Arts: An International Comparative Study*. Washington, DC: National Endowment for the Arts.

Shisko, R. and Rostker, B. (1976) The Economics of Multiple Job Holding. *American Economic Review*, 66, 298–308.

Stinson, J. F. (1987) Moonlighting: A Key to Differences in Measuring Employment Growth. *Monthly Labor Review*, February, 30–31.

_____. (1990) Multiple Jobholding Up Sharply in the 1980's. *Monthly Labor Review*, July 1990, 3–10.

_____. (1997) New Data on Multiple Jobholding Available from the CPS. *Monthly Labor Review*, March, 3–8.

Throsby, D. (1994) The Production and Consumption of the Arts: A View of Cultural Economics. *Journal of Economic Literature*, March, 1–29.

Throsby, D. and Thompson, B. (1994) *But What Do You Do For a Living? A New Economic Study of Australian Artists*. Redfern, Australia: Australia Council for the Arts.

_____. (1995) *The Artist at Work: Some Further Results from the 1988 Survey of Individual Artists*. Redfern, Australia: Australia Council for the Arts.

Towse, R. (1996) *The Economics of Artists' Labour Markets*. London: Arts Council of England, ACE Research Report No. 3.

Wassall, G., and Alper, N., (1999) Employment and Earnings of American Artists: 1940–1990, unpublished manuscript.

_____. (1985) "Occupational Characteristics of Artists: A Statistical Analysis." Journal of Cultural Economics, 9, 13–34.

Wassall, G., Alper. N., and Davison, R. (1983) *Art Work: Artists in the New England Labor Market*, Cambridge, MA: New England Foundation for the Arts.

APPENDIX

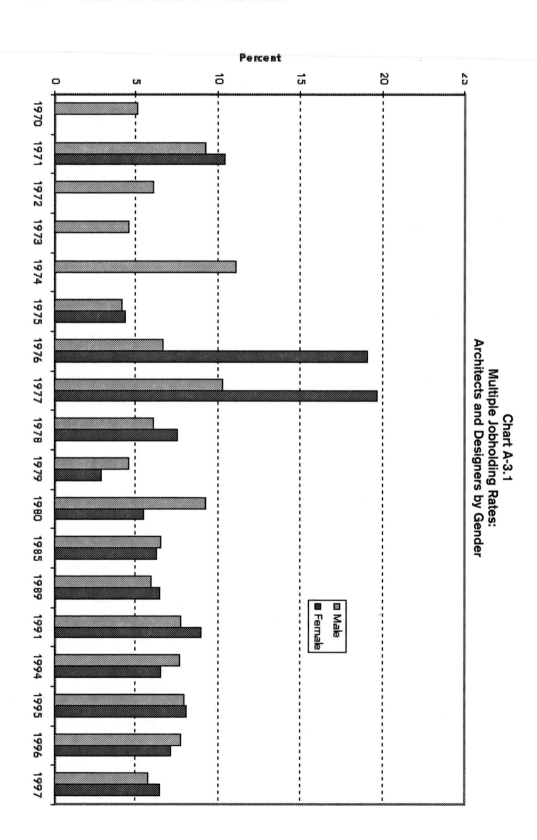

Chart A-3.1
Multiple Jobholding Rates:
Architects and Designers by Gender

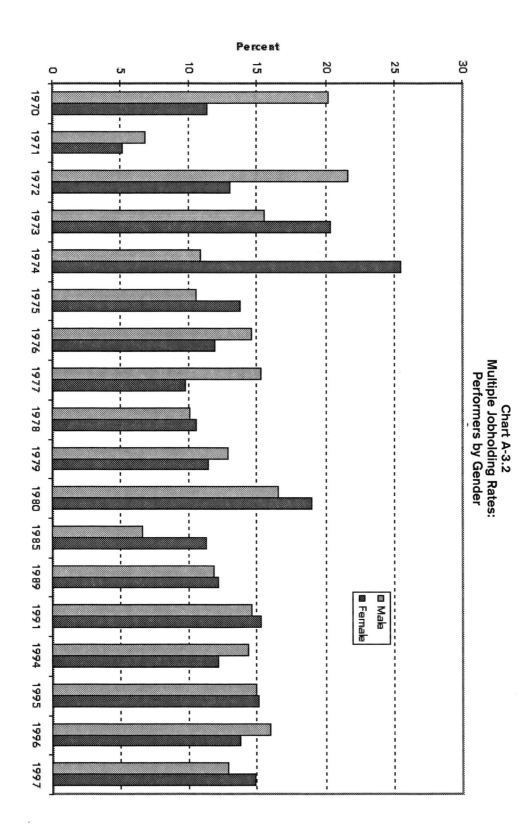

Chart A-3.2
Multiple Jobholding Rates:
Performers by Gender

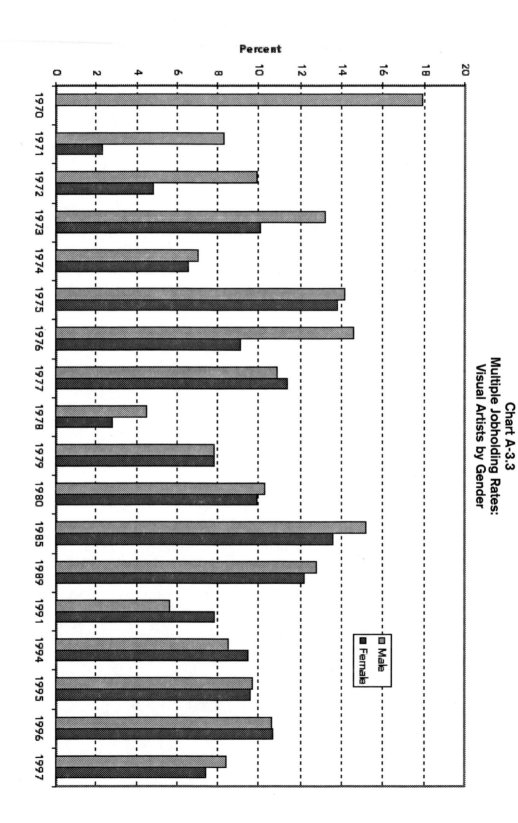

Chart A-3.3
Multiple Jobholding Rates:
Visual Artists by Gender

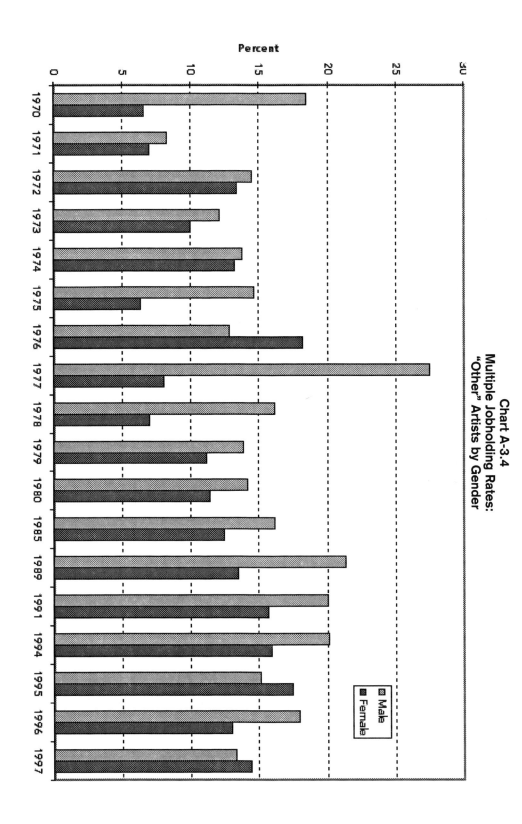

Chart A-3.4
Multiple Jobholding Rates:
"Other" Artists by Gender

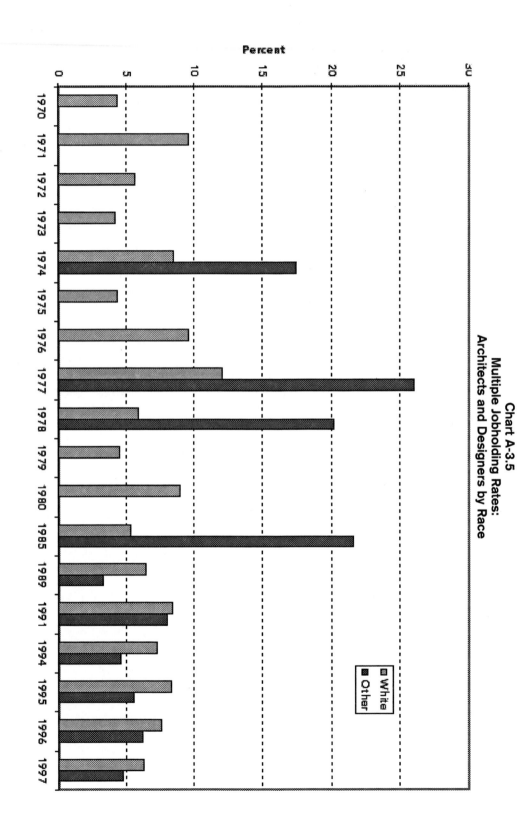

Chart A-3.5
Multiple Jobholding Rates:
Architects and Designers by Race

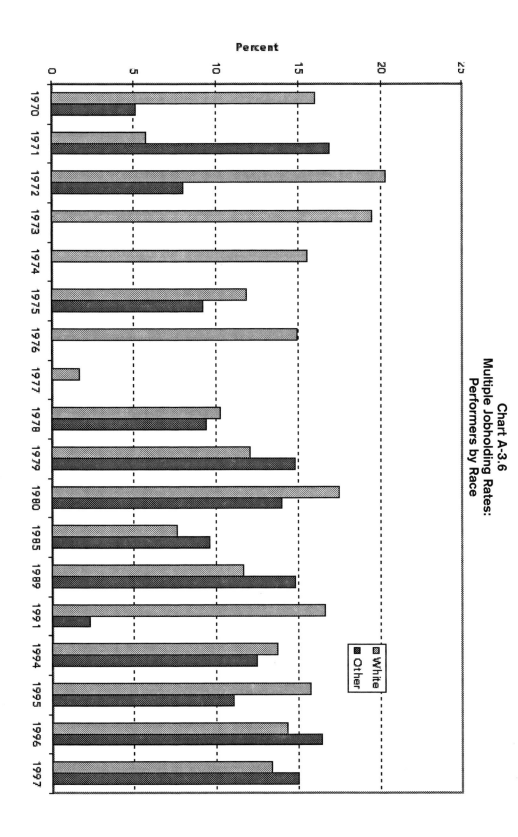

Chart A-3.6
Multiple Jobholding Rates:
Performers by Race

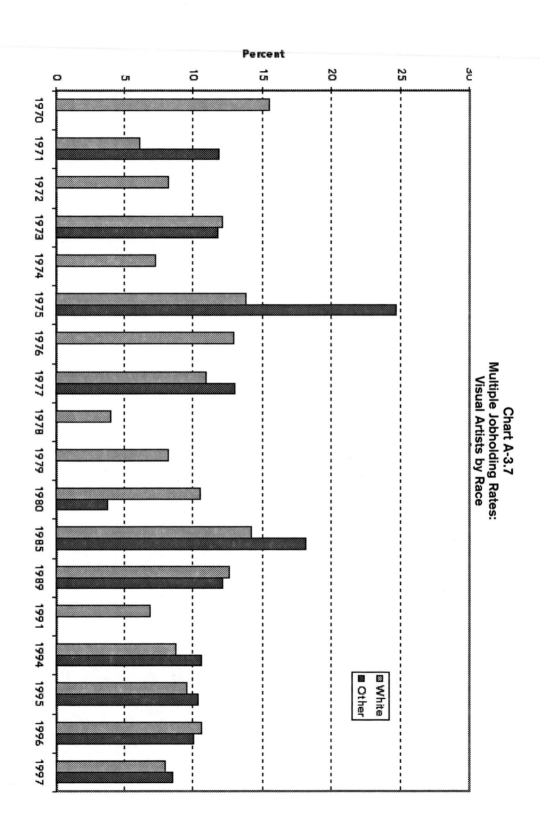

Chart A-3.7
Multiple Jobholding Rates:
Visual Artists by Race

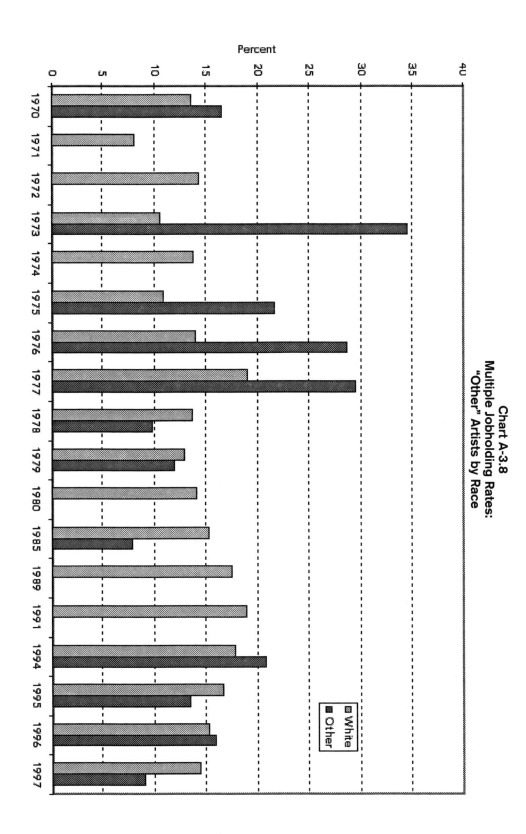

Chart A-3.8
Multiple Jobholding Rates:
"Other" Artists by Race

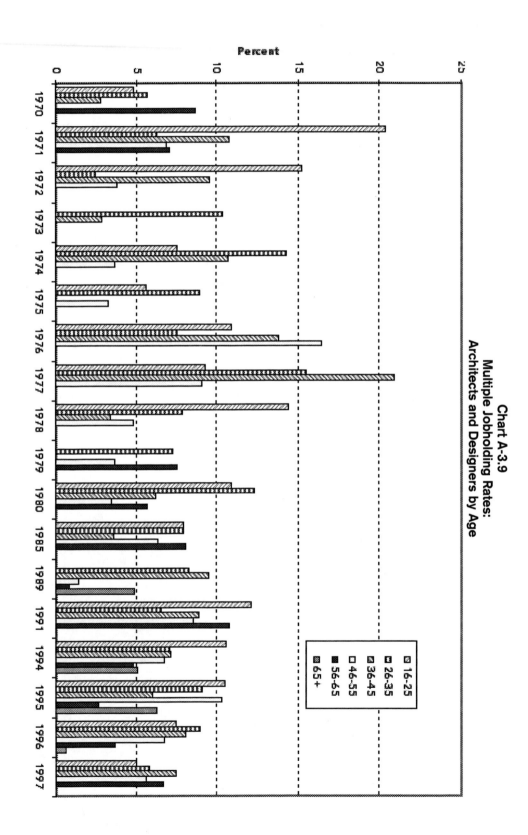

Chart A-3.9
Multiple Jobholding Rates:
Architects and Designers by Age

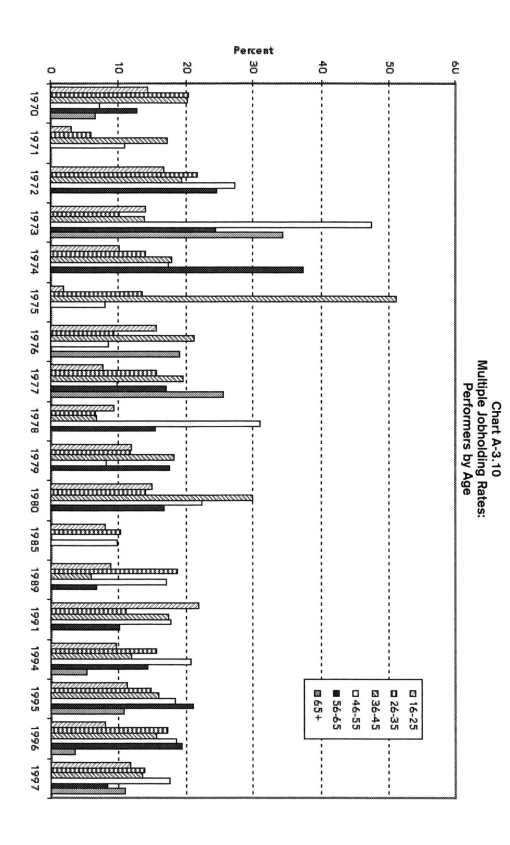

Chart A-3.10
Multiple Jobholding Rates:
Performers by Age

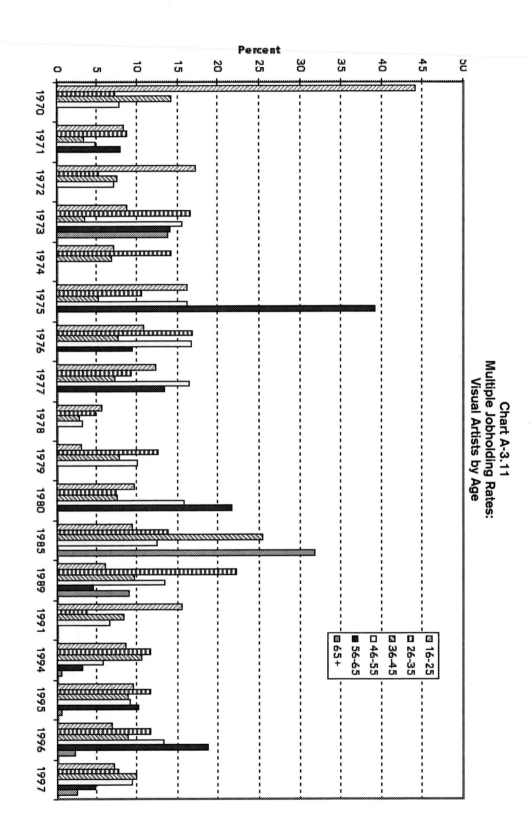

Chart A-3.11
Multiple Jobholding Rates:
Visual Artists by Age

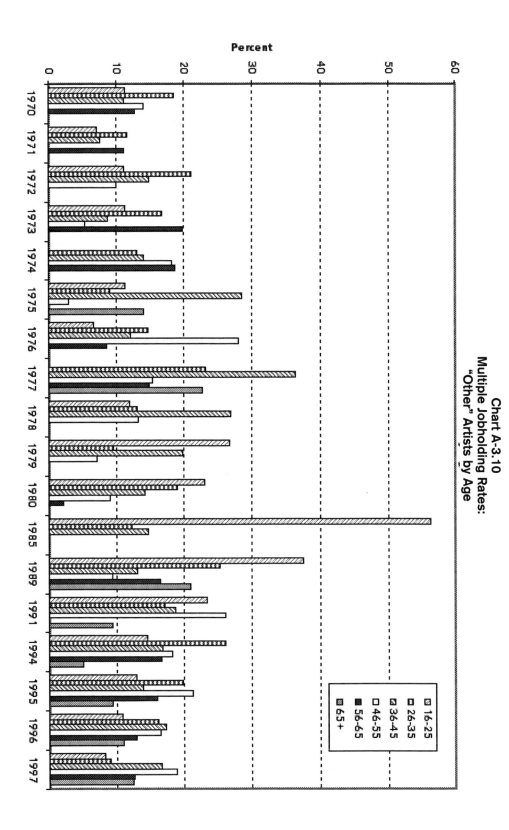

Chart A-3.10
Multiple Jobholding Rates:
"Other" Artists by Age

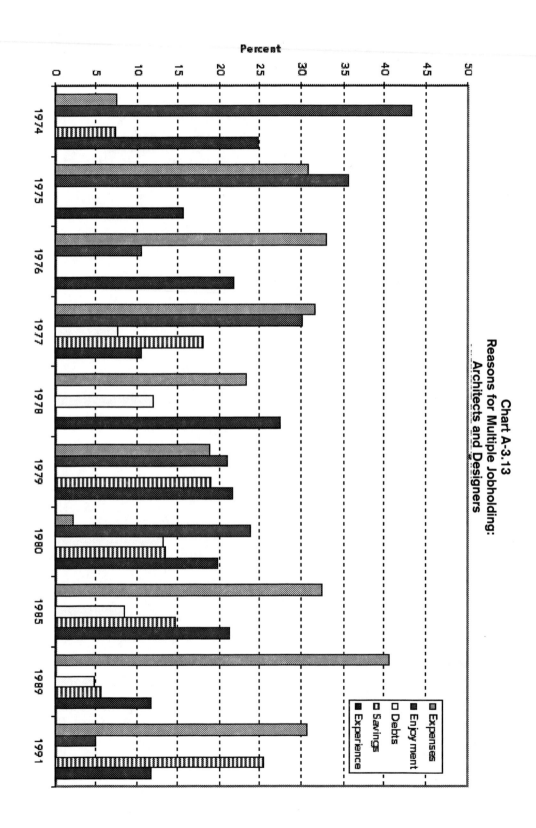

Chart A-3.13
Reasons for Multiple Jobholding:
Architects and Designers

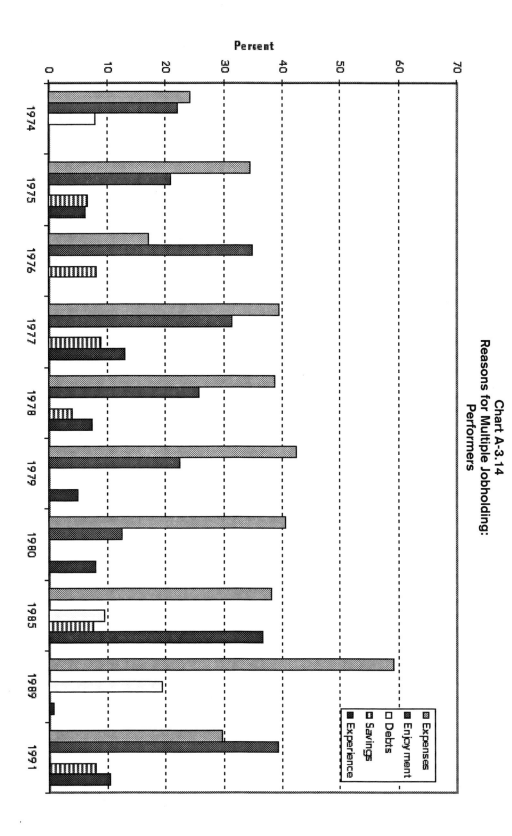

Chart A-3.14
Reasons for Multiple Jobholding:
Performers

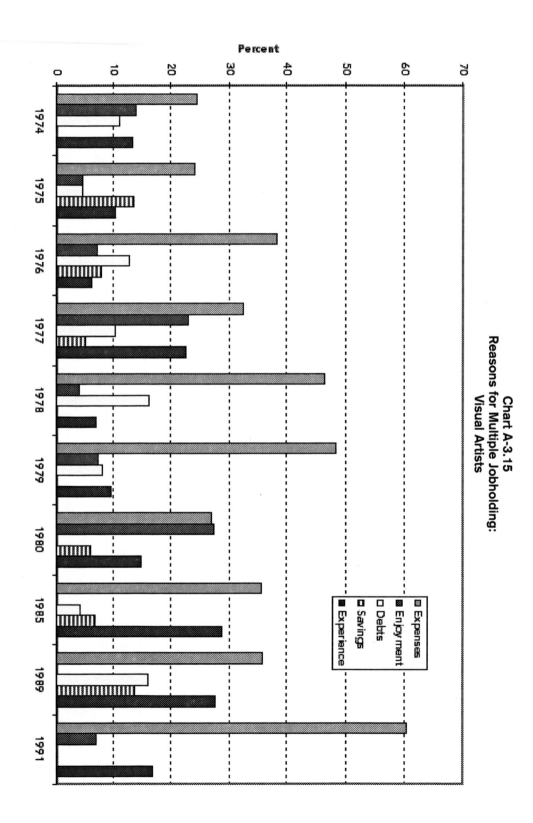

Chart A-3.15
Reasons for Multiple Jobholding:
Visual Artists

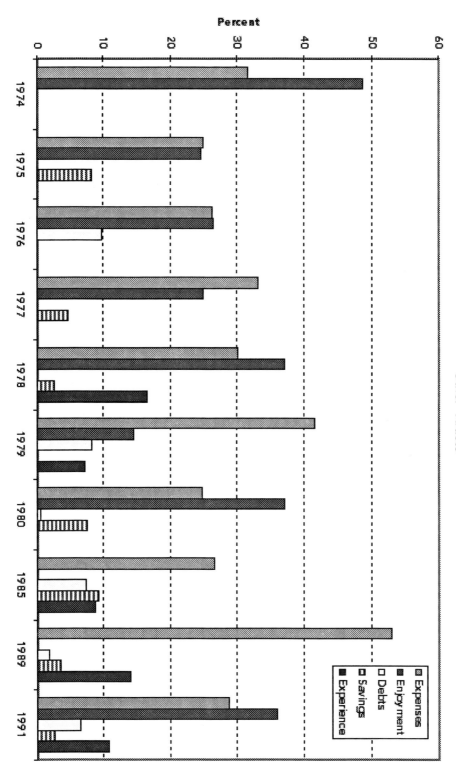

Chart A-3.14
Reasons for Multiple Jobholding:
"Other" Artists

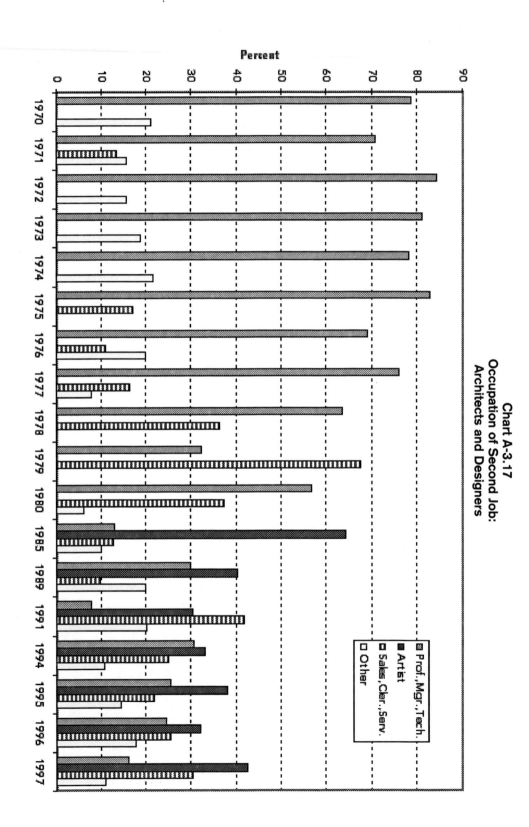

Chart A-3.17
Occupation of Second Job:
Architects and Designers

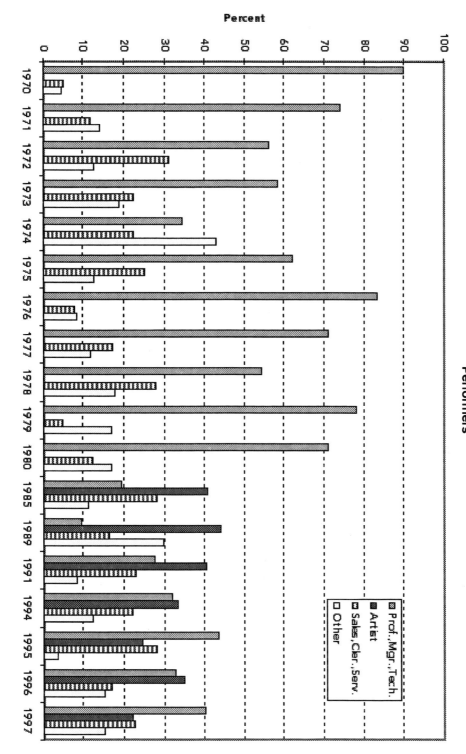

Chart A-3.18
Occupation of Second Job:
Performers

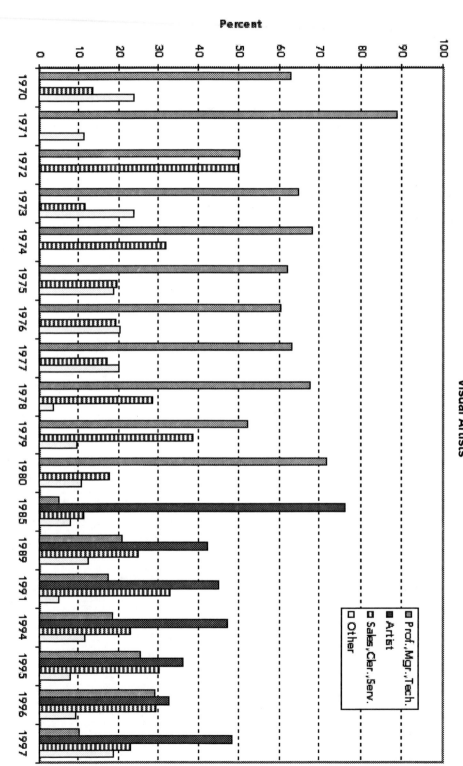

Chart A-3.19
Occupation of Second Job:
Visual Artists

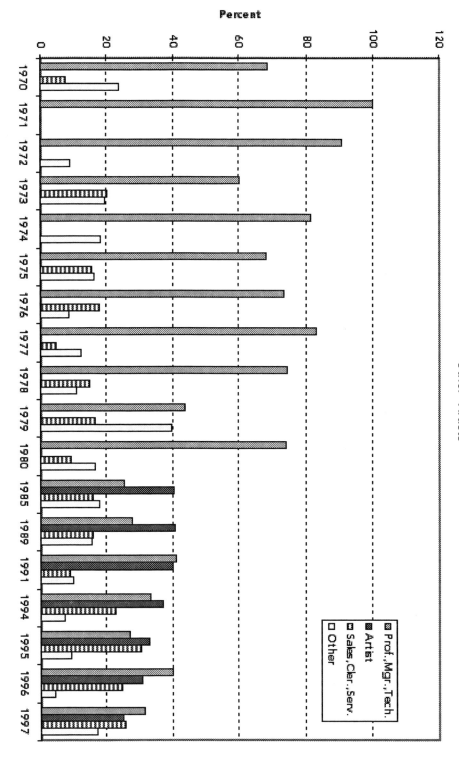

Chart A-3.20
Occupation of Second Job:
"Other" Artists

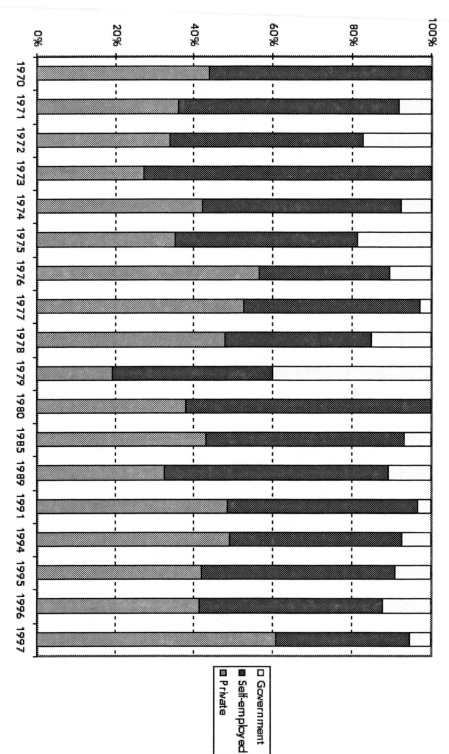

Chart A-3.21
Sector of Second Job:
Architects and Designers

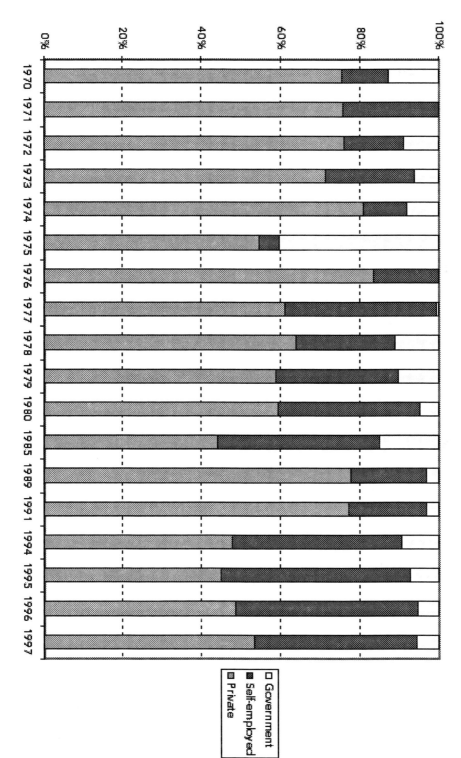

Chart A-3.21
Sector of Second Job:
Performers

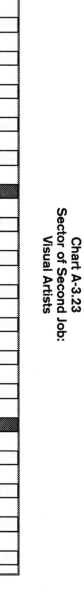

Chart A-3.23
Sector of Second Job:
Visual Artists

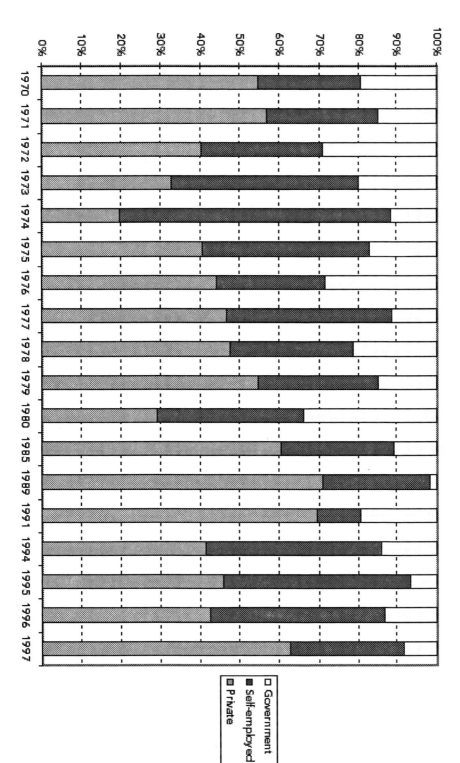

Chart A-3.24
Sector of Second Job:
"Other" Artists

□ Government
■ Self-employed
▨ Private

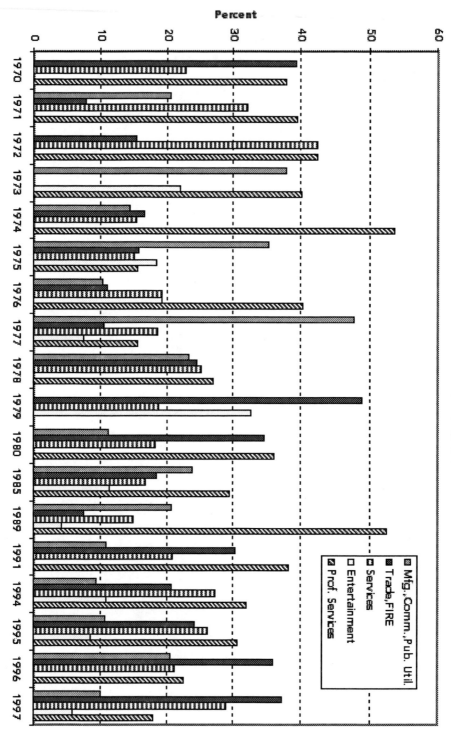

Chart A-3.25
Industry of Second Job:
Architects and Designers

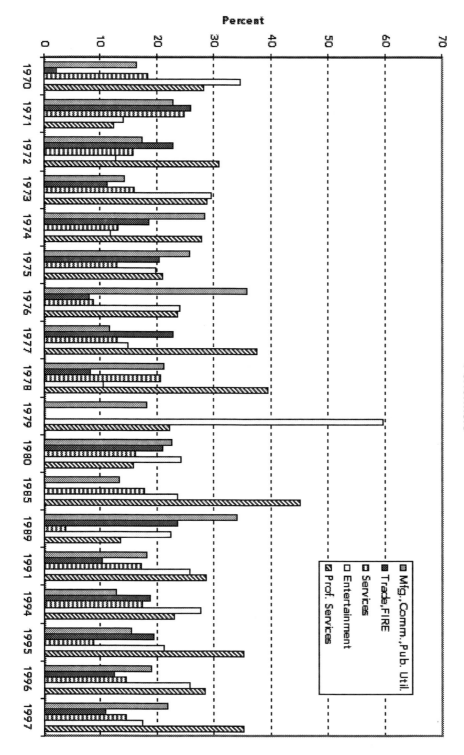

Chart A-3.26
Industry of Second Job:
Performers

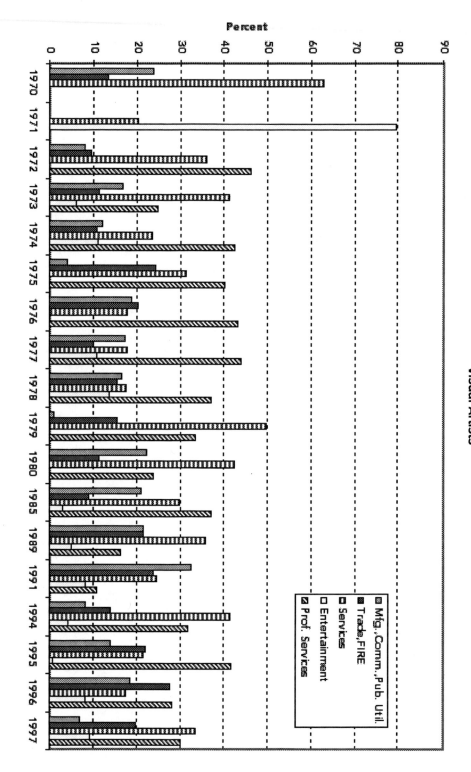

Chart A-3.27
Industry of Second Job:
Visual Artists

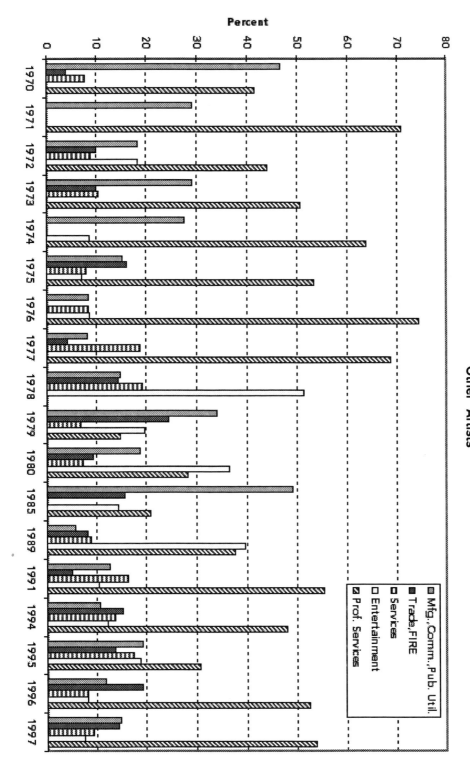

Chart A-3.28
Industry of Second Job:
"Other" Artists

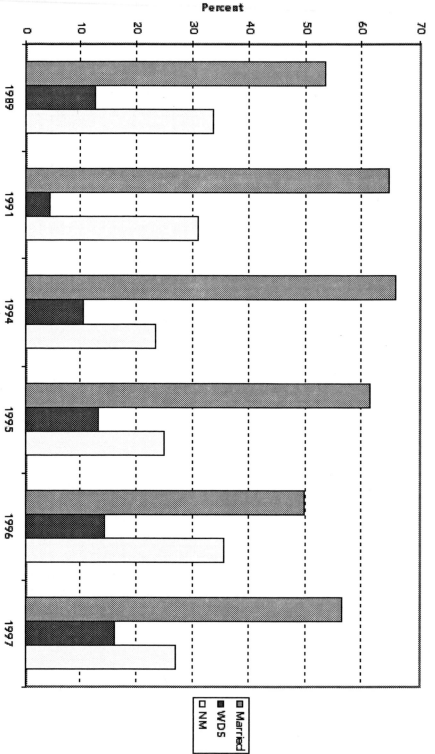

Chart A-3.29
Multiple Jobholding Artists:
Marital Status-Architects and Designers

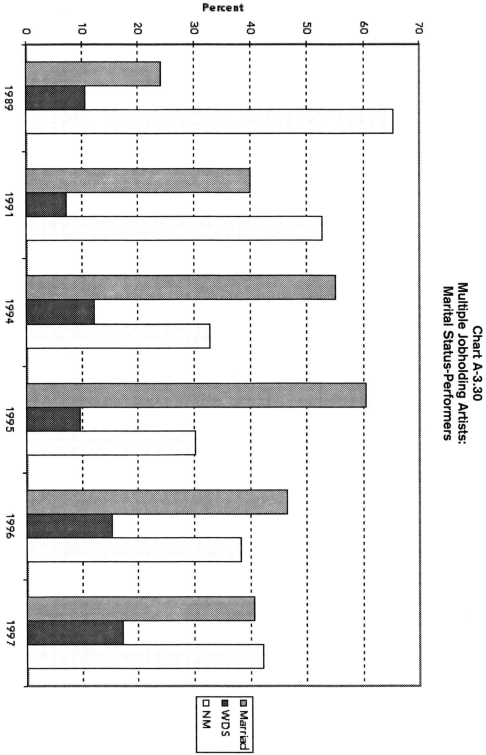

Chart A-3.30
Multiple Jobholding Artists:
Marital Status-Performers

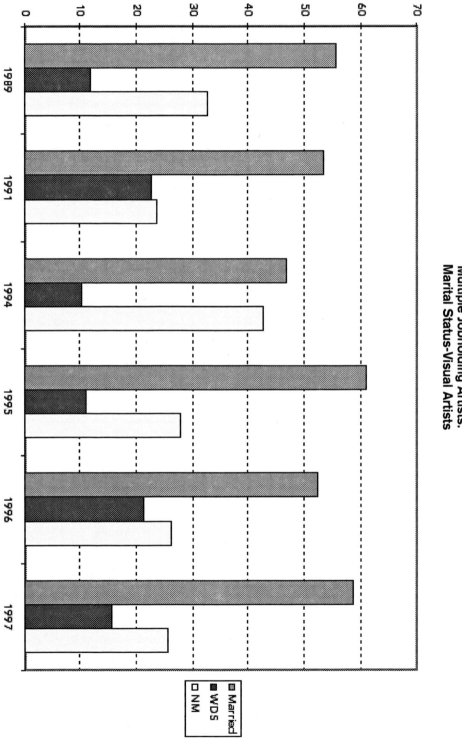

Chart A-3.31
Multiple Jobholding Artists:
Marital Status-Visual Artists

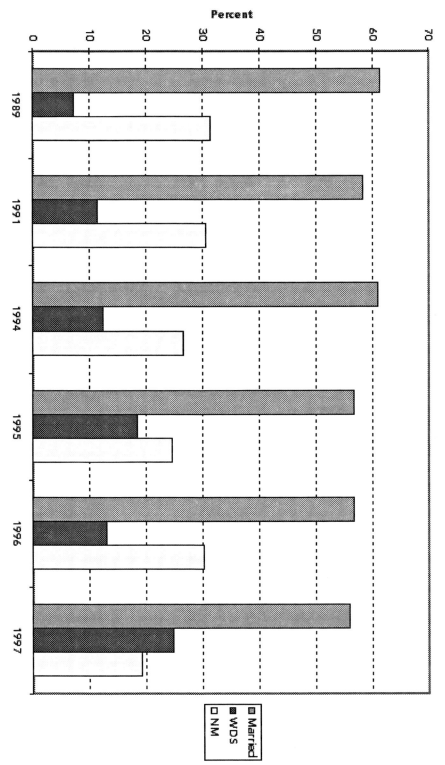

Chart A-3.32
Multiple Jobholding Artists:
Marital Status-"Other" Artists

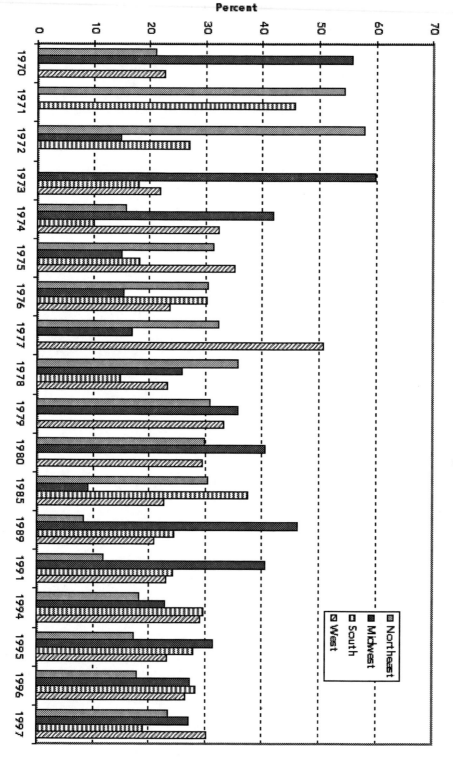

Chart A-3.33
Multiple Jobholding Artists:
Region-Architects and Designers

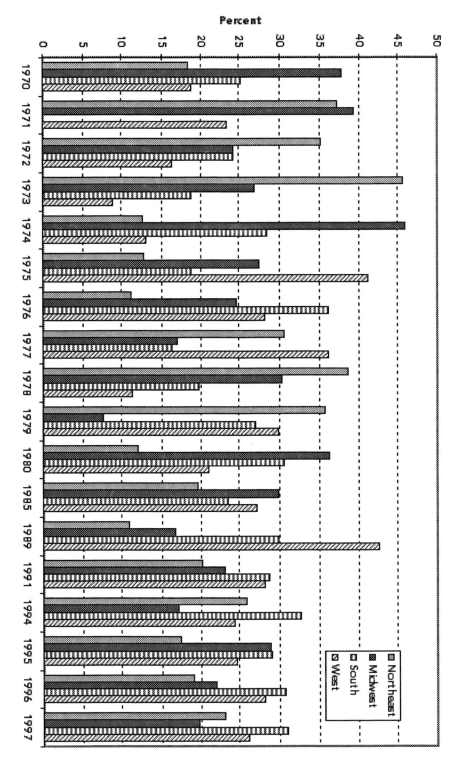

Chart A-3.34
Multiple Jobholding Artists:
Region-Performers

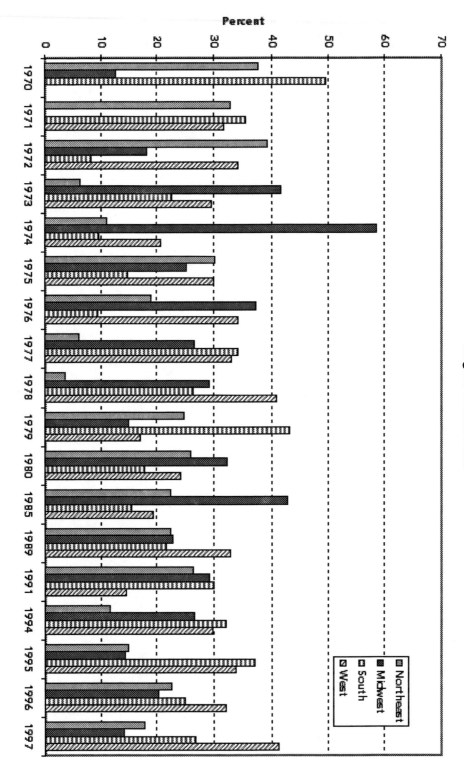

Chart A-3.35
Multiple Jobholding Artists:
Region-Visual Artists

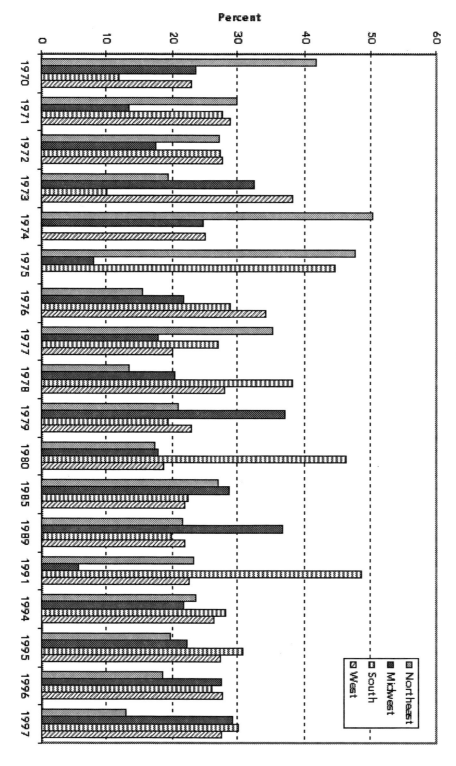

Chart A-3.36
Multiple Jobholding Artists:
Region-"Other" Artists